MORAY COAST
FROM CULLEN TO CULBIN
THROUGH TIME
Jenny Main

D1615364

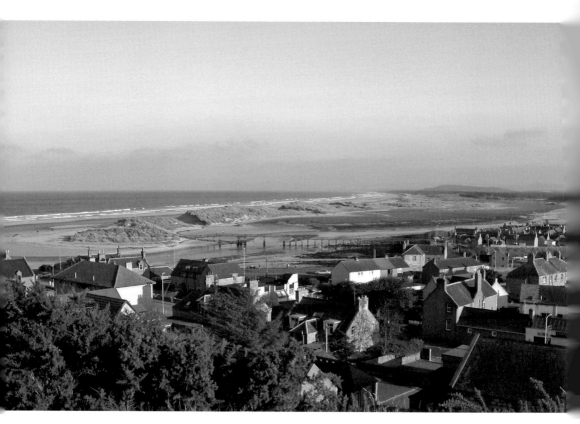

Seatown, Lossiemouth.

First published 2011

Amberley Publishing
The Hill, Stroud
Gloucestershire, GL5 4EP

www.amberley-books.com

Copyright © Jenny Main, 2011

The right of Jenny Main to be identified as the
Author of this work has been asserted in accordance
with the Copyrights, Designs and Patents Act 1988.

ISBN 978 1 84868 929 9

British Library Cataloguing in Publication Data.
A catalogue record for this book is available from
the British Library.

Typeset in 9.5pt on 12pt Celeste.
Typesetting by Amberley Publishing.
Printed in the UK.

Contents

Acknowledgements

Many thanks are due to the enthusiastic volunteers from Cullen Heritage, Buckie Heritage, Fochabers Heritage, Elgin Museum and Findhorn Heritage – they have lent old photographs for this project and given cheerfully and generously of their time and information. For anyone with the slightest interest in the area these Heritage centres are all well worth a visit and worthy of support.

Thanks are also due to Janet Trythall and Jane Thomas for some splendid old postcards, Honor Third and Meg Murray, Jim Skelton for old photographs and information and to Jean Stocks for some stunning modern views.

The dolphin photograph has been generously donated by Charlie Phillips, on behalf of the Whale and Dolphin Conservation Society.

The Forestry Commission has kindly allowed the use of illustrations by Drew Smith.

Terry Campbell donated aviation pictures and Joe Kennedy allowed the use of his own aerial photographs, all of which have given a fascinating perspective of the area.

Most importantly, this book would not have been possible without the practical help, photographs, transport, technical support and endless supplies of patience from Brian Loveland, to whom I am so very grateful!

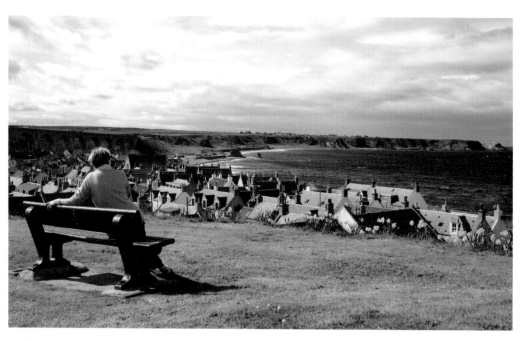

Cullen Bay.

Introduction

The River Spey once marked the eastern coastal border of Moray, but following a change in Parliamentary boundaries in 1975, the map was redrawn. Now the Moray District of Grampian region takes in Banffshire, the coastline stretching as far east as Cullen while its western border lies in the great swathe of Culbin.

The Moray coast contains a wide variety of scenery – rocky coast line, shifting shingle, rugged cliffs, sheltered bays, glorious stretches of sandy beaches and the largest dune system in Britain. Birdlife is plentiful and otters, seals, badgers and deer inhabit an area where once beaver, wolves, and wild boar roamed.

Over the millennia there have been vast coastal changes round the mouths of the three main rivers. The Spey remains in a constant state of turmoil, the shingle banks at its mouth relentlessly changing in size and shape. The Lossie once poured into the vast sheltered bay of Spynie loch, which stretched beyond Duffus. The Findhorn estuary has altered frequently, shifting sands in the estuary consuming the village and farmlands.

Dinosaurs wandered over the land which is now used as a quarry – the Hopeman sandstone in which they left their footprints has recently been used to clad buildings such as the new museum in Edinburgh, and to repair Barcelona Cathedral. The waters of the Moray Firth are home to the world's most northerly population of bottlenose dolphins, which share waters with fishing boats, oil rigs, tankers and the occasional cruise liner.

Flint arrowheads, Bronze Age settlements, burial cairns, standing stones, promontory forts, Pictish carvings and Roman coin hoards all leave intriguing hints into Moray's past. Only faint remains are left of the many eighteenth-century shipyards and ports, while many of the once-bustling fishing harbours now only shelter pleasure craft.

In the early days, settlements formed around small inlets or beaches and the fishermen went to sea in open boats with no protection. Wealthy eighteenth-century landowners set up new coastal communities to take advantage of the growing fishing industry. Established hamlets were demolished and old, haphazard and unsanitary communities replaced by redesigned villages set well away from the landowner's residence. The construction of harbours began in the early nineteenth century, the fishing industry rapidly expanded and the new railway system was vital in maintaining the fishing and the supporting industries which sprung up around the harbours.

During the Second World War, many air bases were to be found throughout the region, all of which played a vital part in the war effort. Since then, two main RAF bases at Kinloss and Lossiemouth have thrived, their personnel bringing many benefits to the local communities as well as playing an essential role on the world stage, and in national security and rescue roles.

The Moray coast has undergone many changes; trying to compress such a diverse range of territory into a short book is challenging – it is only possible to give a small flavour of a region that is full of fascinating stories, constant surprises and glorious scenery.

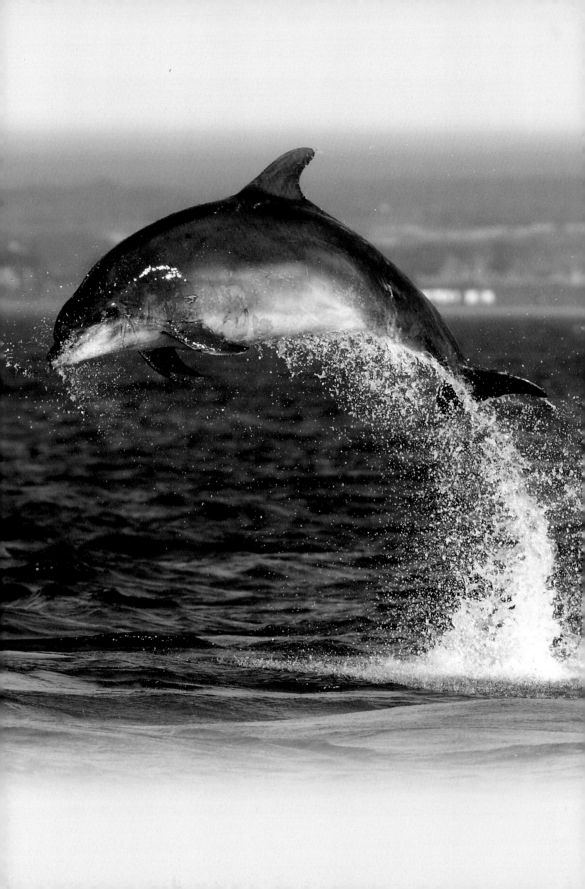

CHAPTER 1

Cullen to Findochty

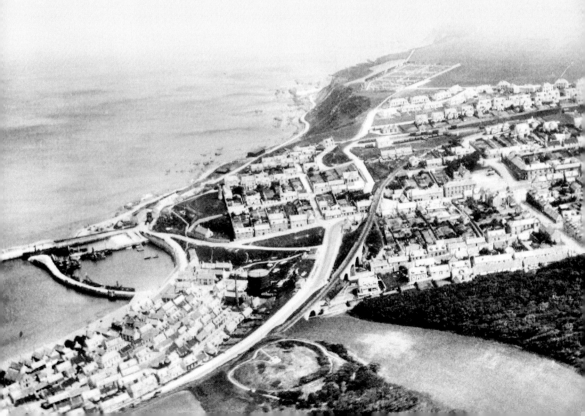

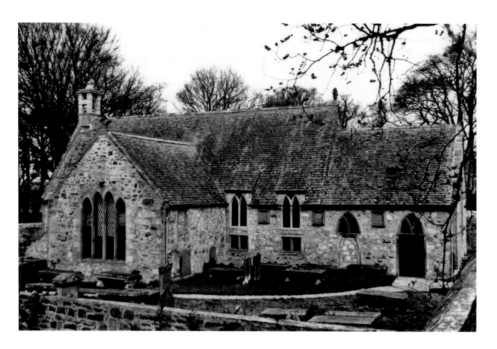

Cullen Old Kirk

The Auld Kirk, dating back to 1236, was the focal point of the old town of Cullen. Robert the Bruce's mother, Martha, had a house nearby and when his second wife, Queen Elizabeth, died in Cullen her 'interiors' were buried here while her body was taken for burial in Dunfermline Abbey. Originally a small chapel, it was promoted to a collegiate chapel in 1543 to enable the singing of masses for the soul of its founders, the Ogilvies from nearby Findlater Castle. The church was used as a stable for the Duke of Cumberland's cavalry on their way to victory over the Jacobites at Culloden. The impressive tombs, once appropriated by the Earl of Fife, have now been returned.

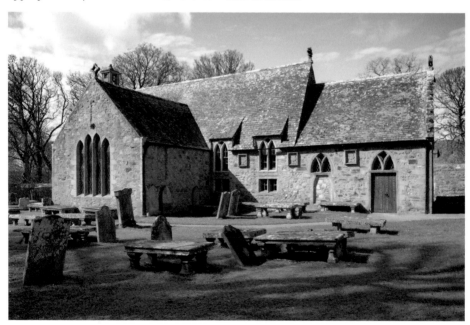

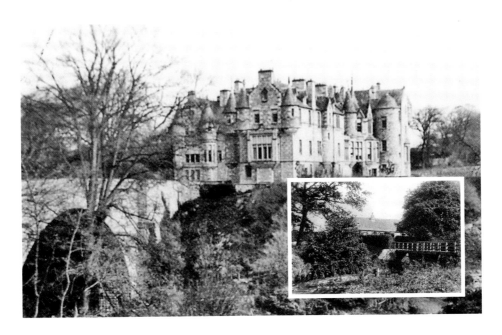

Cullen House and Lintmill

Overlooking the Deskford burn, Cullen House stands on the foundations of a thirteenth-century building, reputedly the home of Martha, mother of King Robert the Bruce. The ancient house was complete with a monk's passage and the oldest stones date from 1543, when members of the collegiate church resided there. Abandoning Findlater Castle, the Ogilvies made it the base for Cullen House in 1600. Nearby Lintmill village was founded by James, Lord Deskford, son of the Second Earl of Seafield, who promoted the linen industry – flax growing, spinning, bleaching and linen manufacturing – which flourished until the early nineteenth century. The Earl and Countess of Seafield moved out in 1975 and, exterior unchanged, Cullen House was eventually converted to a series of private dwellings.

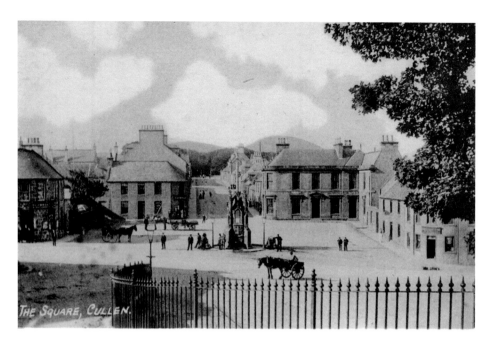

THE SQUARE, CULLEN.

Cullen Square

The original twelfth-century settlement of Invercullen began around the castle before moving close to the church, possibly after destruction by Edward I. In the seventeenth century, Old Cullen was plundered and almost destroyed twice by Montrose. The population prospered with linen manufacturing in the mid-1700s but, with the industry's decline, the town decayed. In 1820 the Earl of Seafield began moving the 500 inhabitants of the dilapidated Old Town to its present site, centred round the square. One of the earliest shops was the corner shop on the square which 'sold everything'. The proprietor, J. F. Grant, was also an emigration agent for Canada and by 1906 had helped 455 emigrants to leave for a new life overseas.

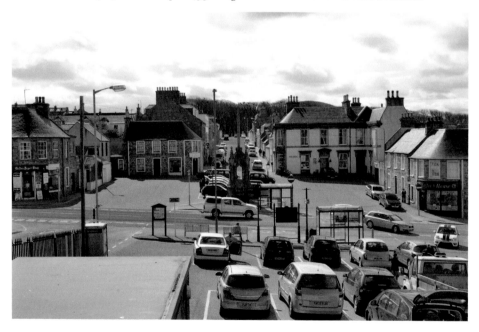

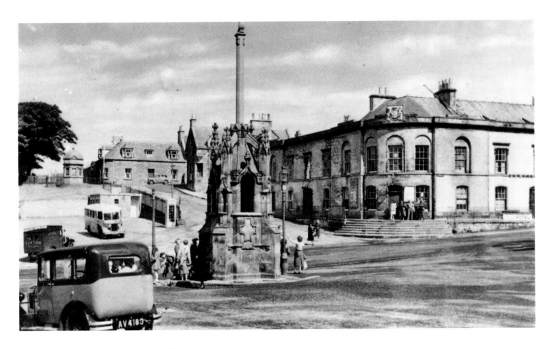

Cullen Square and Market Cross

Originally beside the parish church of Old Cullen, the market cross was moved in 1821 to Castle Hill. This was the site of an Iron Age fort, then later a baronial stronghold around which developed the original settlement of Invercullen. In 1872 the cross was re-erected in Cullen Square, incorporating the seventeenth-century shaft of the former cross. The Town Hall, destroyed by fire in 1942 and reconstructed in the 1950s, bears a plaque carrying the Seafield Arms which was once on the gateway to Cullen House. The adjoining Seafield Arms (formerly the Cullen Hotel), once a coaching inn with smithy and stables, was the stopping place where the Banff to Elgin stagecoach picked up the mail each day.

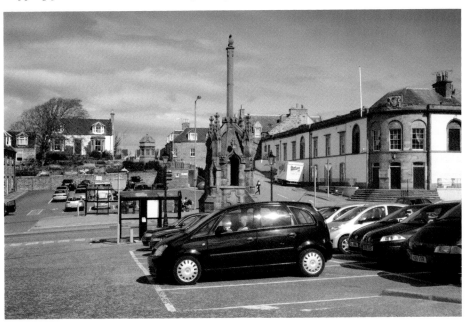

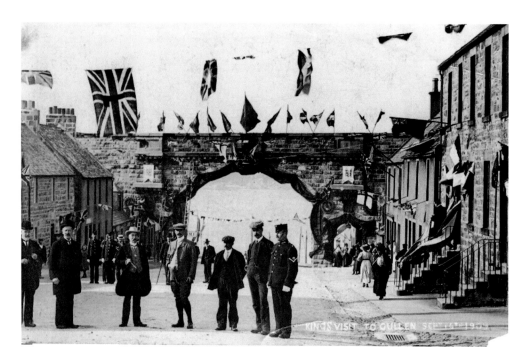

Looking to the Kings

The old photograph shows Seafield Street prepared for the visit of King Edward VII, who stayed at Cullen house in 1909. His hostess was the widowed Lady Seafield, who died in 1911, having kept the estate intact and almost managing to pay off inherited debts. Through the arches on adjoining North Castle Street can be seen the beach where fishermen once hauled their boats up for the winter. On this beach, rocks known as The Three Kings are named for Norse invaders who landed here in 961 prior to their defeat at the Battle of the Bauds. The inn is named after these distinctive quartzite outcrops.

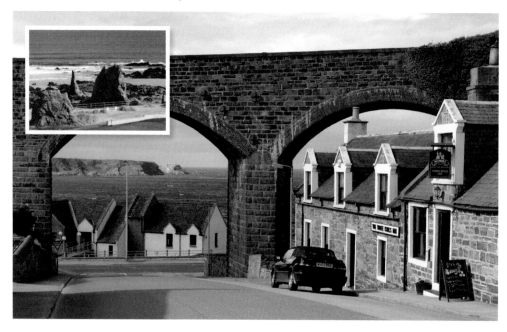

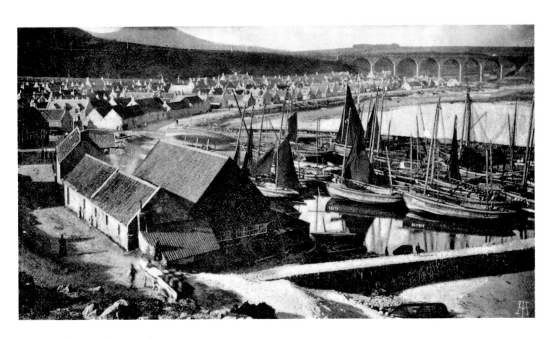

Cullen Harbour and Seatown

Crofters were evicted from Old Cullen in 1613 to start a fishing industry. The original houses were 'clay and daub', built with pebbles from the beach, thatched and with open lofts for storing nets. By the late 1800s, the peak of the herring industry, over 250 fishermen resided in Seatown, the community including sail-makers, chandlers, granary, a fish-curing station and ship-building yard where the sturdy zulu fishing boats were built. With little protection from the sea, the residents built a crude rubble barricade reinforced with refuse. Following fierce storms which flooded Seatown, the present sea wall was built in 1953. By the 1930s Cullen was a dormitory town, and nowadays pleasure craft berth in the B-listed Thomas Telford harbour.

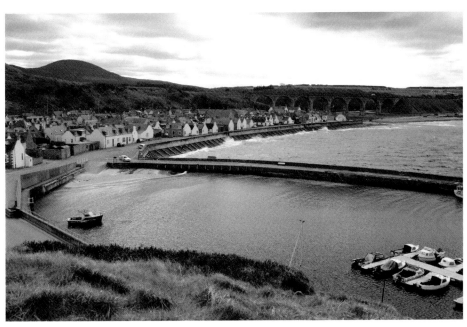

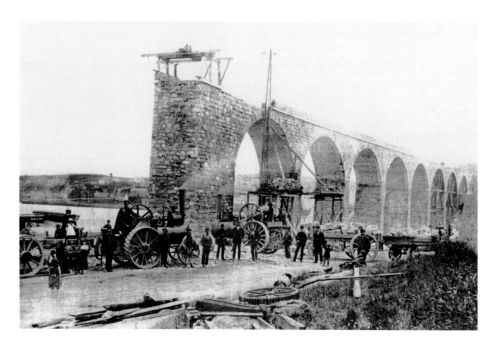

Cullen Viaduct and Seatown

Before the advent of the railway, sailing vessels were the main means of transporting heavy goods. The Countess of Seafield refused permission for the railway to go through the grounds of Cullen House. Consequently, viaducts had to be built for the Great North of Scotland Railway coast line, linking the coastal communities of Banffshire. The Cullen viaducts, opened in 1886, were built by Irish navvies working alongside local men, using steam tractors and horses. The largest, crossing the Deskford Burn with eight immense arches, is 24.8 m high. The line was closed in 1967 and the viaducts were taken into the care of Moray Council, and now form part of a cycleway. Portknockie is on the horizon in the new photograph.

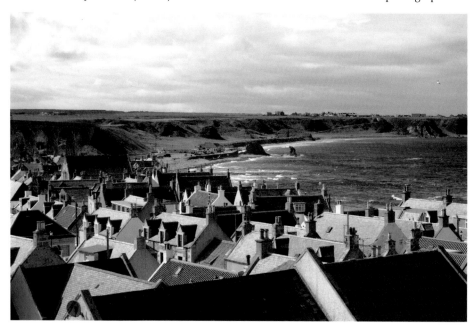

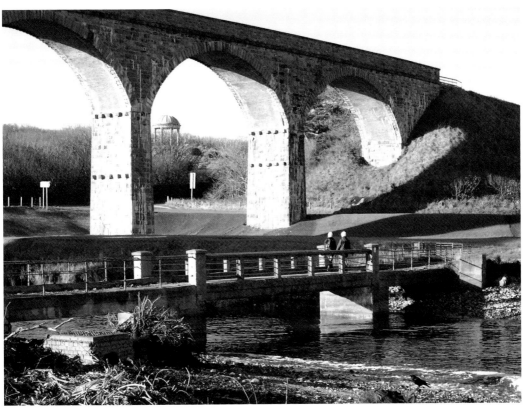

The Temple of Pomona

Visible through the viaduct arches in the modern picture is the Temple of Pomona, built around 1822 on top of Dunnineen's hillock. A statue of Pomona, goddess of Fame, was once beneath the dome, but vanished during the Second World War. In the lower part of the structure was a wooden panelled room, used by the Seafield family for a tea room and as a changing room when enjoying bathing trips to the beach. Before the arrival of the railway embankment, the hill led directly to the seashore and there was a private path from the Temple to the beach. In order to give continued access, a tunnel was created to the beach when the main road was built.

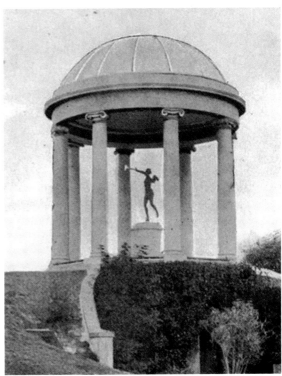

15

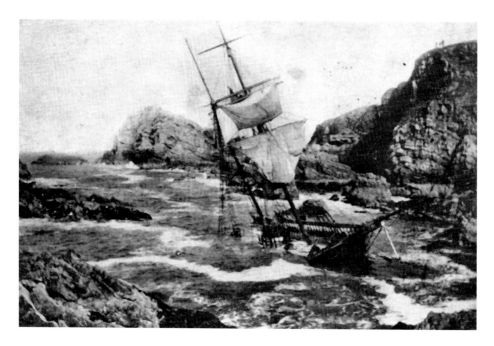

Deceptive and Deadly Shore

Throughout the generations, the caves and rocks along this picturesque stretch of coast have seen many human dramas. Countless vessels have foundered on the treacherous rocks and many lives lost. Amongst the wreckage of one sailing ship, the body of the cabin boy was found clinging to the drowned captain. All individually named, the caves along this stretch of coast were used by smugglers and sheltered Jacobite fugitives. To the east, beyond Cullen harbour and towards Findlater Castle, is 'Charlie's cave', where hermit Charlie Marioni lived a self-sufficient life in a crude hut for nearly twelve years, making furniture from driftwood, catching fish and growing vegetables. Evicted in 1933 by the landowner, he died a pauper three years later in England.

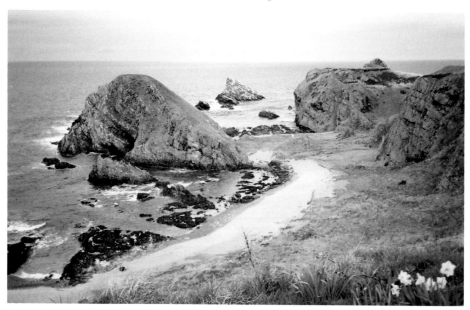

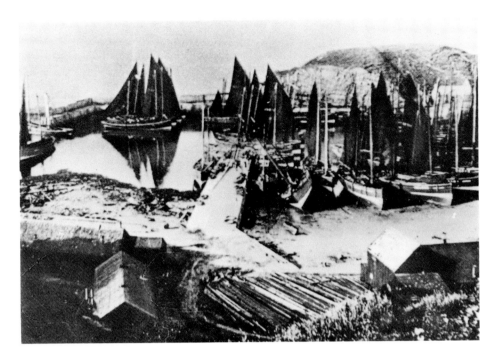

Portknockie Harbour

Beyond the promontory of Scar Nose, a short way past the colony of seabirds on the quartzite Bow Fiddle rock, lies the snug harbour of Portknockie, founded as a fishing village in 1677 by fishermen from Old Cullen. The east of the harbour is overlooked by the promontory of Green Castle, on which a defensive oak timber-laced wall was erected in 700 AD upon a previous Bronze Age site. The harbour once held up to 150 fishing vessels, some built in the village. Nowadays, just a few small boats land their creels here amongst the pleasure boats. On the cliffs above the tide-filled paddling pool are many fine houses built for the ships' captains during the 1800s fishing boom.

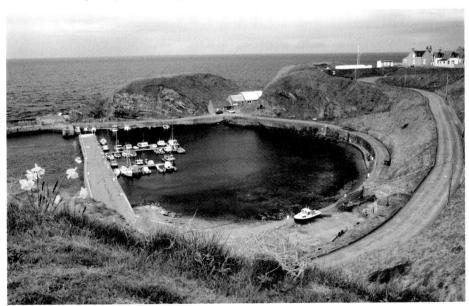

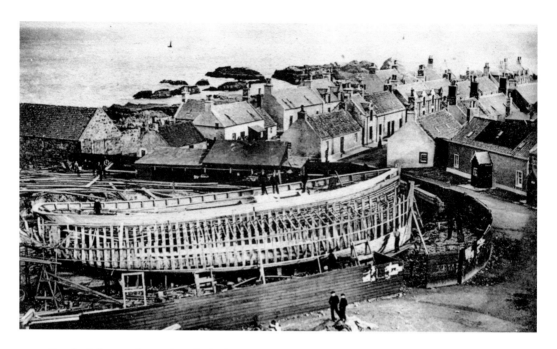

Boatbuilding at the Hythe, Findochty

The Hythe church looks down upon the site of the old Findochty boatbuilding yard. The earliest documentary reference to Findochty was in 1440, when a small community crowded around the natural harbour of Crooked Haven. In 1568 the Findochty lands were acquired by the Ord family. A village developed around the harbour, and in 1716 Thomas Ord contracted thirteen men and four boys from Fraserburgh to found a fishing station here. The population eventually rose from 43 to 166 by the end of the century, and by 1920 there were 182 fishing households. Boatbuilding took place at the Hythe, but now hardly any trace of this industry is visible and the old slipway is now a picnic site.

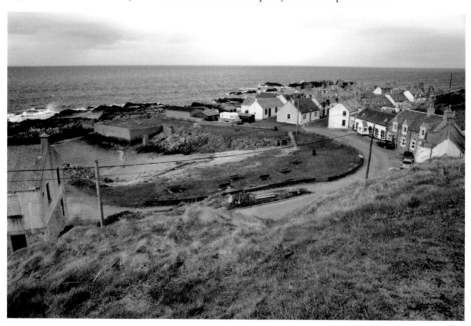

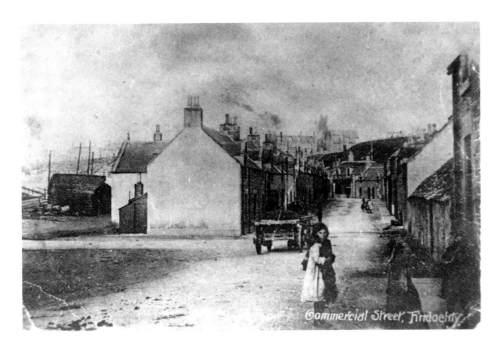

Commercial Street, Findochty

Originally in Banffshire, and once known as Findachtie, the modern local pronunciation of the village name is Finechty, originating, some experts believe, from the Gaelic for white tub. In 1899, evidence of prehistoric man was discovered in a cliff cave near the present bowling-green. Horn spoons and needles and a broken armlet were amongst the finds. The cave was later blasted and the rock used for road and house building, and any further evidence lost. Slightly inland, the sixteenth-century castle was sited at the end of a drained loch. Further inland, the moor of Findochty has many cairns, supposedly marking graves of those slain fighting the Danes at the Battle of the Bauds in 961.

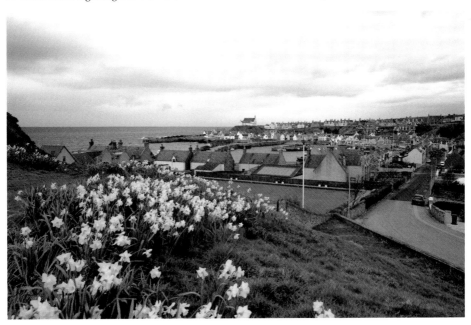

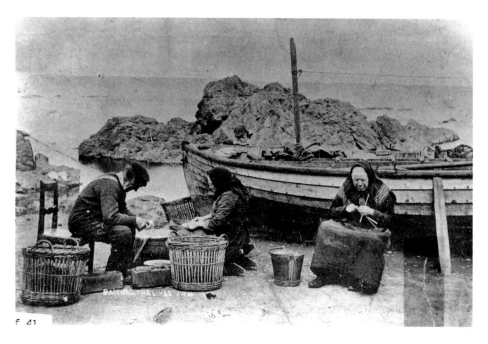

F 41

Then and Now – Work and Leisure

Boats were run into two natural openings at Findochty until the harbour was built in the 1880s; the combination of railway and harbour then boosted Findochty's fortunes. The prominent Gothic-style church on the skyline overlooks the Hythe and was built in 1860 for the United Presbyterian congregation, mostly seceders from the parish church of Rathven during the religious upheavals of the time. With accommodation for 400 it acted as a landmark for fishermen, and also as a lighthouse. Until the bell was installed in 1887 the congregation was called to worship by a foghorn. A sheltered caravan park now overlooks the rock formation known as Edindoune and dolphins are often seen passing by in nearby waters.

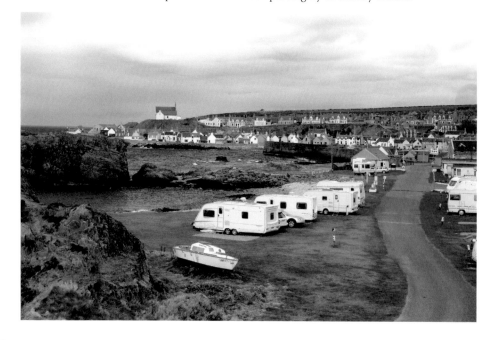

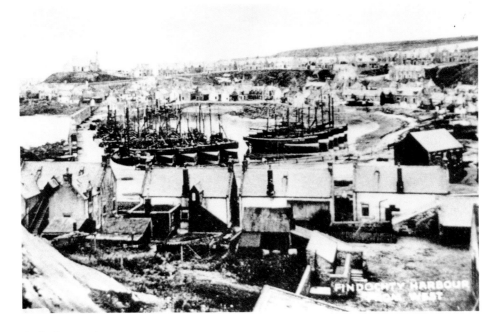

Findochty Harbour

With the improvement in fortunes brought by the harbour and railway, many new houses were built above the Findochty brae – between 1886 and 1896, their numbers doubled. The harbour was full of hard-working fishing boats – mostly zulus and steam drifters. In the 1890s large quantities of herring were shipped from Findochty to the Baltic markets, and at one time only Buckie had more fishing boats on this stretch of coast. When, in 1887, Buckie eventually expanded and created a better harbour, the Findochty fleet began mooring there and Findochty became a quieter place. An 1880 painting by James Clarke Hook, *Home with the Tide*, hangs in the Tate gallery, London, immortalising the hard-working Findochty fisher folk of the past.

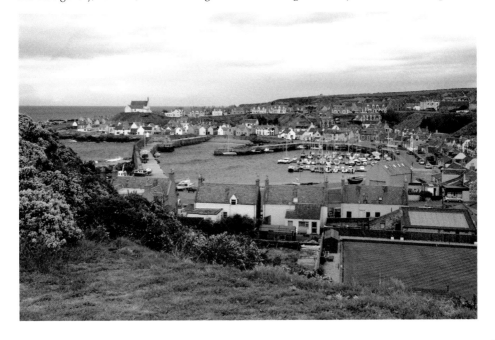

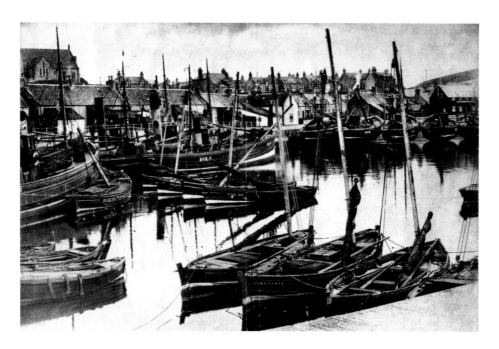

Lost Generations

The pre-First World War postcard shows Findochty harbour, looking west, with the svelte zulus moored alongside the more modern steam drifters. Even more dramatic changes lay ahead. By the 1920s, following the depression in fishing industry, there were 'very few marriages and a number of houses set free by emigration' in Findochty. By 1955 only a few working boats remained, and nowadays the harbour shelters mostly pleasure craft. A statue of a seated fisherman, by Correna Cowie, watches over the harbour with the inscription 'They see the works of the Lord and his wonders in the deep'. Above the western cliff top and the caravan site, the twentieth-century War Memorial overlooks the village and the harbour.

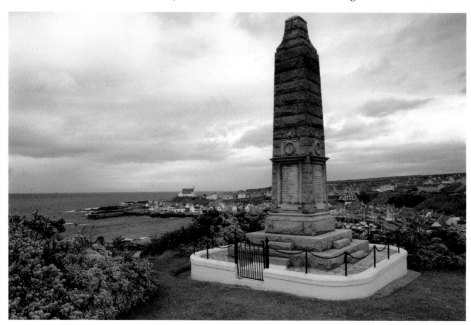

CHAPTER 2

Portessie, Buckie & Portgordon

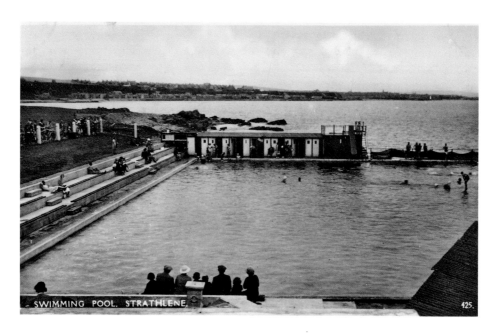

Strathlene Pool, Portessie, with Buckie on the Skyline

A salmon fishing station was once on the Strathlene foreshore. An outdoor swimming pool with changing cubicles was opened in 1932 and became a popular venue for galas, school sports and holidaymakers. The Great North of Scotland Railway brought many visitors to Strathlene, but by the late 1950s holidays became popular, visitor numbers fell and the pool gradually fell into disrepair. Despite the poor condition, in the early 1970s Strathlene pool was still in use for school sports and galas. Eventually Buckie's new indoor pool opened and the sun decks and changing rooms at Strathlene became derelict, lying abandoned until 2005 when the remaining buildings were demolished and the pool filled in. Only the outer walls now remain.

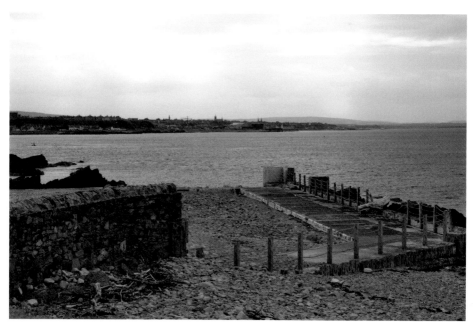

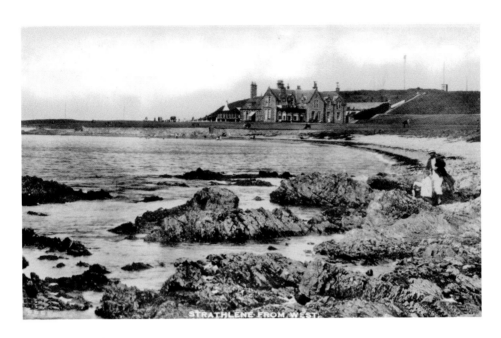

STRATHLENE FROM WEST.

Strathlene, Looking East

Strathlene house and grounds were once the home of the factor of the Seafield estate, but were acquired by Buckie Town Council in 1931. As well as the swimming pool, a putting green and new eighteen-hole golf course was developed and the wooden Buckie railway station dismantled and reassembled as the clubhouse. Strathlene House was converted into a boarding house and tea rooms. Static rail carriages were hired out as holiday homes. Local ministers were even drawn to preach to the crowds there on Sunday afternoons in the hopes of increasing their flock! Unable to compete with the burgeoning foreign holiday business, the pool fell into decline. However, the cliff-top golf course, now with modern clubhouse, continues to flourish.

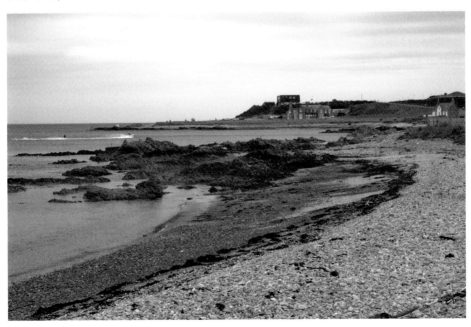

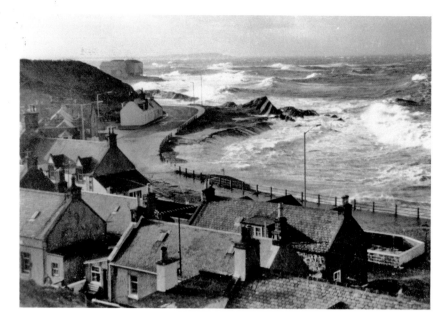

Portessie, Looking West, and the VAD Hospital

Nicknamed 'The Sloch', Portessie was formally known as Rottinslough. Founded as a fishing station in 1727, five houses were built by the proprietor for the original fishermen who came from Findhorn. The little village of Rathven lies slightly inland from Portessie and Rathven church, built 1794, near the original ancient church and graveyard, is the burial place of generations of the ancient landowning families of the area. A bede house, founded for lepers in 1226, stood nearby and, although no longer a leper hospital, was still in existence in 1840. As the influence of Cullen collegiate church increased, the pre-Reformation church of Rathven fell into decline. The church hall in Portessie was used as a VAD hospital during the First World War.

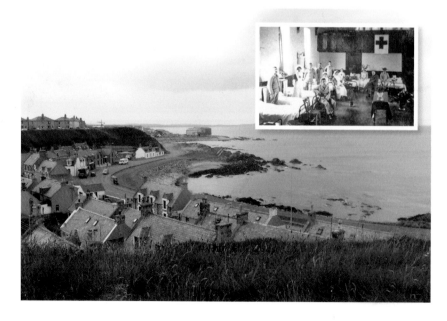

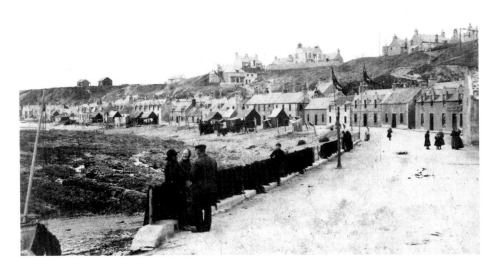

Portessie Foreshore

The British Fisheries Society was set up 1786 to encourage the industry and the construction of villages, harbours and roads. By 1885 the little village of Portessie had expanded, with 145 fishing boats employing about 300 men and boys, and the total population exceeded 1,000. Introduction of the drift net enabled development and expansion of the fishing industry. Around 1860 the bulky hemp nets were superseded by the lighter and more durable cotton nets. Along with the start of trawling in 1882, the developing rail system was also instrumental in the expansion of the industry. The GNSR station at Portessie was built on top of the cliff overlooking Strathlene, and from 1884 Portessie was a terminus of the Highland railway.

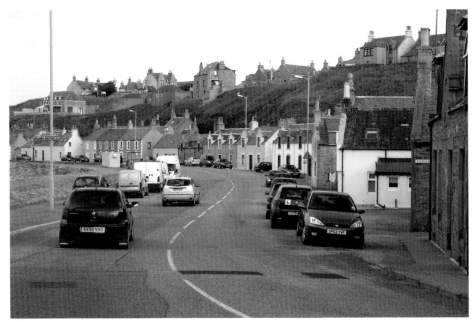

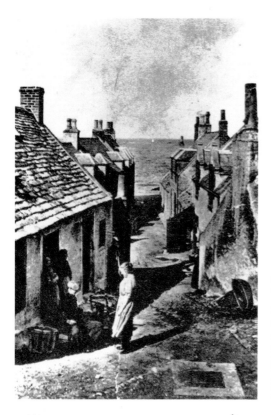

Rannas Place, Portessie

The earliest fishing cottages were 'bools and clay' – local stone bedded on a mix of clay and straw or chopped heather. Low-roofed with straw or heather thatch, the floor of beaten earth or clay, they were frequently built with the gable end to the shore for protection from the winds and waterproofed with lime wash, often coloured with local ingredients – cow urine gave a gentle pink shade. During the early days of processing, fish guts were flung onto the nearby middens and eventually sold to farmers and crofters for fertiliser. Later houses were built of quarried stone with tiles or pantiles replacing thatch. The rocky cove below Rannas Place now shelters families of eider ducklings instead of fishing boats.

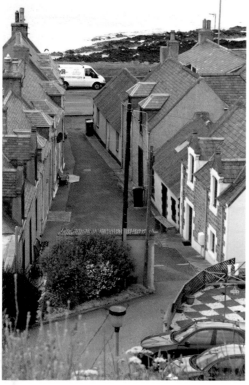

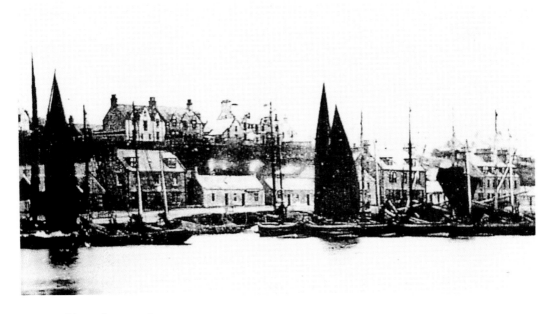

Buckie – Cluny Harbour

Protracted disputes between lairds meant serious fishing was hindered by the lack of a proper harbour. Having witnessed a disastrous storm of 1860, Gordon of Cluny left money to build a harbour which was completed in 1878, the fish-market becoming the heart of Buckie town. The urban sprawl of Buckie grew from a conglomeration of several distinctive fishing villages – the extensive history retained in the invaluable Buckie Heritage centre. A lifeboat station was established in 1860. Human bones once discovered in the harbour area were reputedly those of Danes retreating from the 916 Battle of the Bauds. In 1847 a substantial military force was sent to quell protesting Buckie rioters, angry at the export of grain during a time of famine.

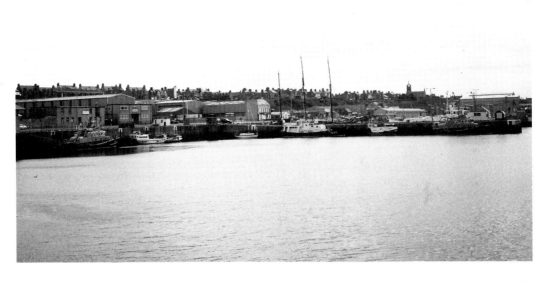

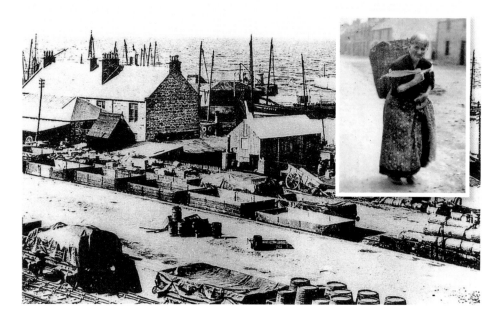

Cluny Harbour from the Railway

Fishing and fortunes changed with the building of Cluny harbour, one of the finest anchorages north of Aberdeen; in 1913, Buckie had the largest steam drifter fleet in Scotland. Fishing boats were once packed so tight that it was possible to walk across the harbour on the decks. Boatbuilding and associated industries burgeoned even more with the advent of the railway. Teams of fisher girls would gut and pack herring into barrels for export to southern and continental markets. The fish wives would carry creels of fish to sell many miles inland. With the decline of fishing, the once-busy boat yards amalgamated and closed. The one remaining is kept busy with repair and refit work and servicing the lifeboats.

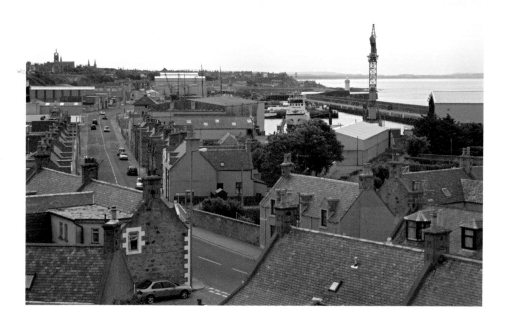

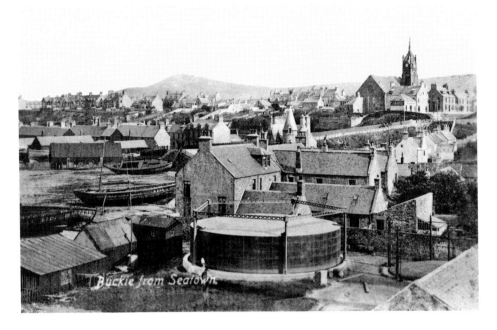

Buckie from Seatown

Buckie from Seatown and the Memorial Chapel

The fisher-folk of Buckie have experienced many tragedies. In 1982, in a converted old chapel, the Seamen's Memorial Chapel was opened in Seatown to commemorate the loss of life at sea of men from this part of the Moray Firth. The past hundred years have seen great changes in boat design, and in more regulated methods of fishing. No more crews go to sea in wooden boats, no squads of fisher lasses gut and pack herring into barrels for Continental markets. In recent years a fish-smoking business, re-located from Lossiemouth, has established itself as a world-famous provider of quality smoked salmon, employing fifty-five workers and exporting as far afield as Moscow, Dubai and Mexico as well as the Continent.

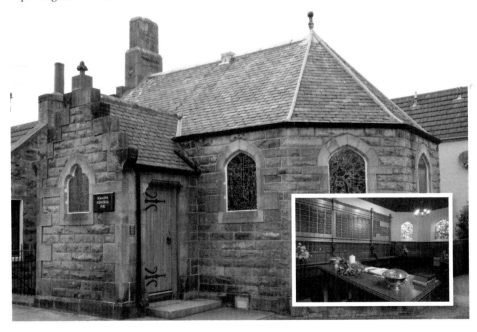

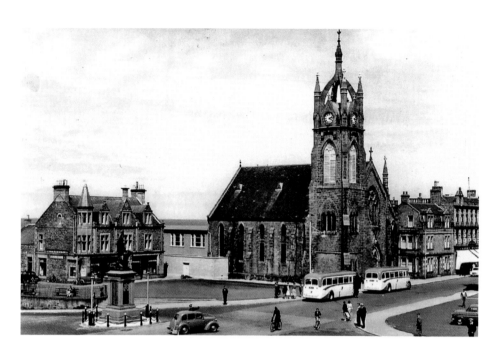

Cluny Square, Buckie

Many fine churches were built in Buckie. The town clock is housed below the distinctive open crown spire of North Kirk on Cluny Square, which opened in 1880. Opened in 1857 and originally planned as a cathedral, St Peter's, with its unmistakable twin spires, was the first Roman Catholic church constructed after emancipation. In 1872 a proposal to change the rates resulted in 3,000–4,000 folk gathering in Cluny Square in protest. Originally sited nearer the North Church, the War memorial in Cluny Square was moved to its present position in 1974. During the Second World War, Norwegians and Danish fishermen fled the Germans and settled in Buckie, supplying the port with fish. A Consulate and Scandinavian mission was set up in Church Street.

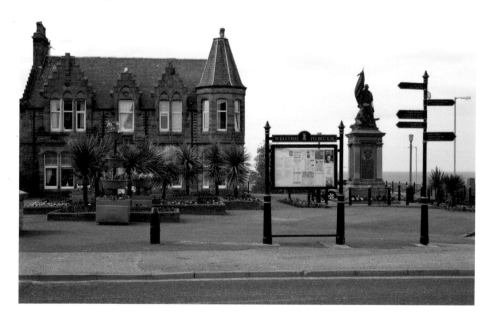

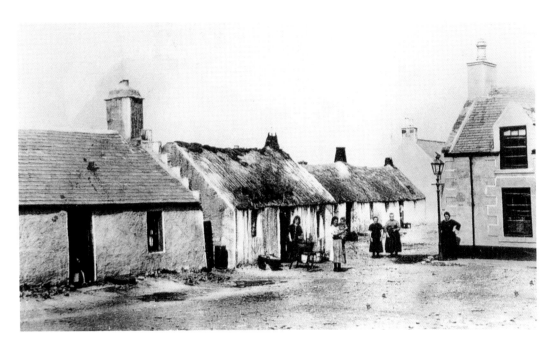

Cat Bow – Through Time

The many fishing villages which make up the Buckie complex still manage to maintain their sense of individuality. Seatown has distinctive and traditional character and the 'Yardie', with its collection of cottages built gable-end to the sea, is now a conservation area. Links with the past are still discovered in the process of upgrading some of these old cottages. One recently modernised cottage in Cat Bow was found to have mussel shells under the floorboards, heaped around the original fireplace. This was poignant evidence of where the first inhabitants, relatives of the present owner, had sat baiting the fishing lines and discarding the empty shells on the original sandy floor.

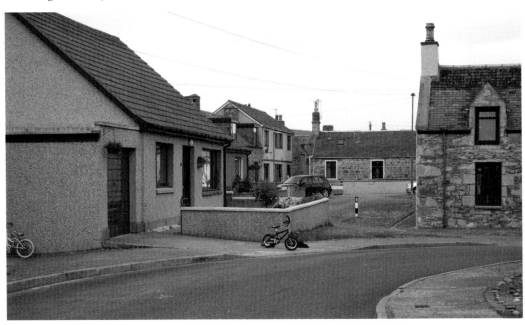

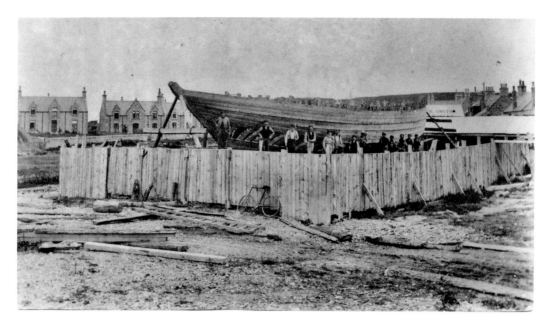

Ianstown

Built on Seafield estate land, the streets of Ianstown are named after members of the Seafield or Grant family and their factors. The little settlement of Ianstown now consists of many more houses, with a few traces of the original layout. From 1894 William Macintosh, boat builder, built thirty-five zulus from his original shipyard here, and from 1904 built sixteen drifters. Many of the different boat construction yards went out of business between the wars, or amalgamated, and their complex but fascinating history can be found at the Buckie Heritage centre. Buckie Shipyard now remains, servicing the lifeboats and with impressive capabilities to build modern vessels of up to 850 tonnes displacement. Today the oil industry provides work for many locals.

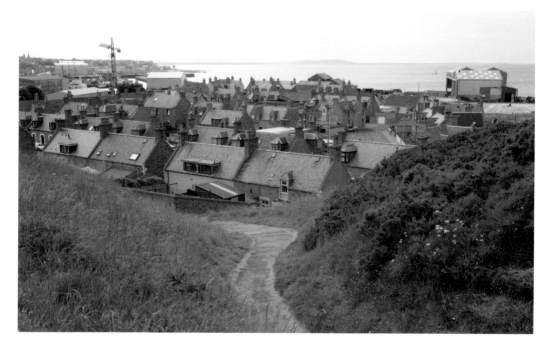

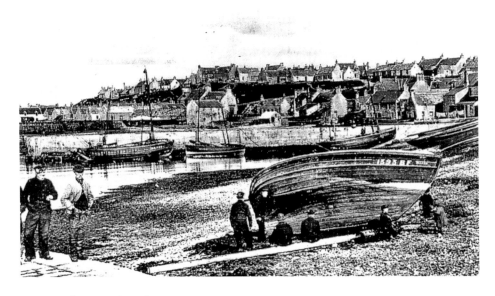

Seatown from Buckpool

The first houses were built at Nether Buckie in 1645, west of the Buckie burn. Connecting with Buckie, the three-arched stone bridge over the burn collapsed in a gale before completion and was finally opened in 1903. Herring boats originally landed their catches onto a wooden and stone pier, between Buckie harbour and Buckie Burn, to be taken away for sale by horse and cart. A wooden harbour was built 100 yards east of the burn, at the Hythie, in 1843, but was soon washed away. The Nether Buckie harbour was built in 1857 and, to distinguish between it and Cluny harbour, Buckie, Nether Buckie was renamed Buckpool. The village also changed its name from Nether Buckie to Buckpool.

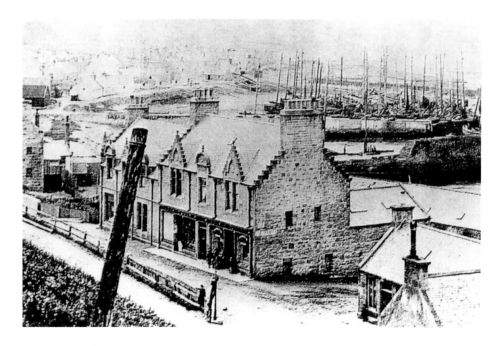

Buckpool Harbour

Buckpool harbour was extended in 1863, but was too exposed to the north-east gales and tended to silt up. At the start of the fishing season in 1896, around thirty larger boats were unable to leave the harbour because of low water. Buckpool became superseded by Cluny harbour, and was used mainly by the smaller lobster and crab fishing boats. It was abandoned in 1964 when shingle and silt made it inaccessible, and work began on infilling. In 1977 the area was landscaped, and Moray District Council won a Civic Trust commendation in 1982 for reclamation of the land. Now part of the Speyside Way, the old fishing harbour has become a play park and a haven for children.

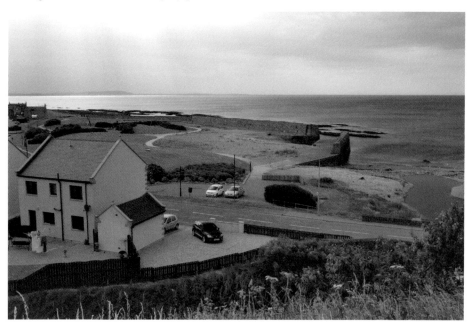

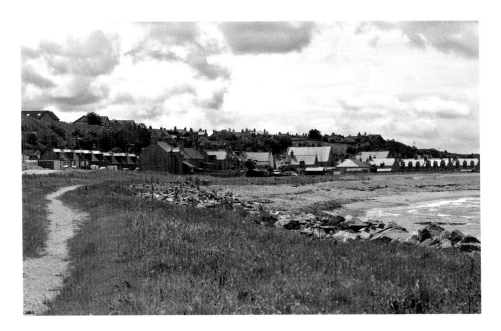

Portgordon Looking Forward, and then Back in Time

Today's picture shows the Speyside Way heading west towards Portgordon. Originally, boats landed through the surf were drawn up above the tide line and nets lain out to dry on the grass. Women-folk assisted in dragging the boats ashore until introduction of windlasses or capstans. Hauling over shingle was easier than over sand. It was common practice for women to carry men ashore or onto the boats, preventing their heavy clothes, socks and leather sea-boots becoming sodden. Drying such items out could prove problematical and wearing wet clothing dangerously debilitating. Women played a vital role in the fishing communities, baiting lines, helping repair nets and hauling gear and men ashore, and also managing the family, household business and chores.

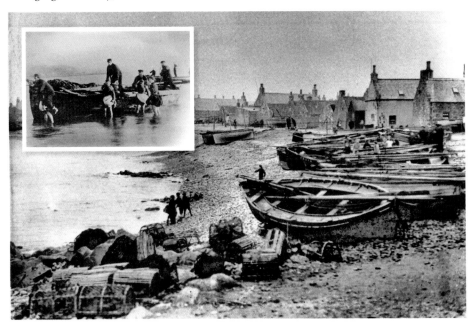

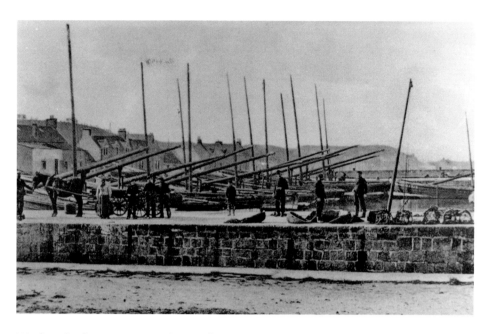

Work and Leisure at Portgordon Harbour

Portgordon was founded in 1797 by Alexander, Fourth Duke of Gordon, who provided ten new houses here for fisher-folk from Buckie. Decline of fishing, war and damage from several gales contributed to the eventual demise of the harbour and it was closed in 1954. The 69th Independent Gurkha Squadron came to the rescue, repairing the harbour in three separate operations between 1985 and 1988. First billeted in Mosstodloch, then Clochan, they endeared themselves to everyone, became honorary members of the community and often worked twelve hours a day to restore the harbour. The Portgordon Harbour group was formed in 2003, to clear the silt and restore the harbour as an attractive leisure facility. They held the first Gala day in 2004.

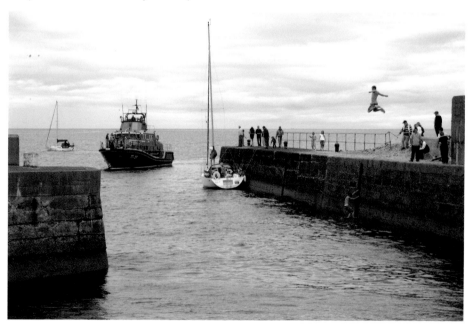

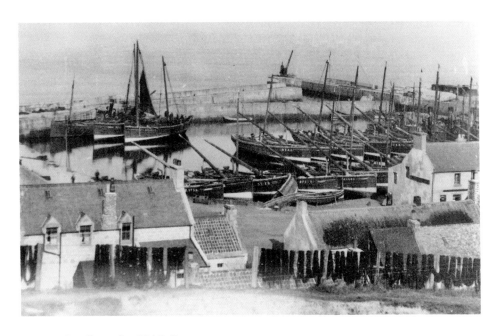

Portgordon from the Old Railway

There was a thriving trade through Portgordon harbour and for a while it was a more important port than Buckie. In 1855 there were sixty boats working from the harbour and 234 fishermen. Exporting grain and importing coal and salt, it soon became a bustling port. Enlargement became necessary: boats carried stone from Burghead quarries and seventy people were employed to build the new harbour which, on completion in 1874, could accommodate 350 fishing boats. Smoke would rise from the 'barking' yard, where nets were tarred. Another important village industry was building the small fishing boats known as salmon cobbles. By 1951 no boats were registered at Portgordon, and the great gales of 1953 and 1983 caused much structural damage.

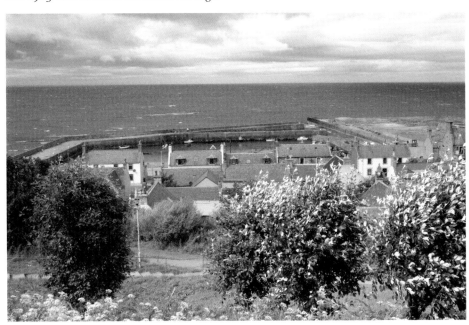

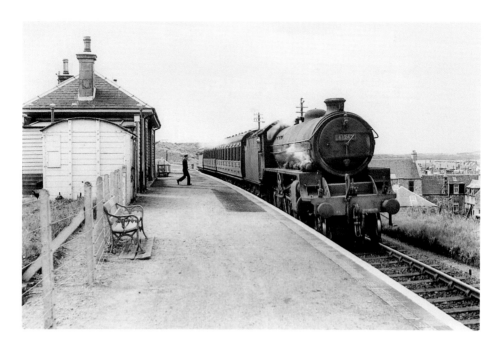

Spying from Portgordon Station

Due to the necessary construction of the Cullen viaducts, the GNSR line did not reach Portgordon until 1886. During the Second World War, the station was the unlikely setting for a spy drama. Three German agents came ashore under cover of darkness. While one went on to Buckie, two agents headed for Portgordon railway station. They aroused the suspicions of the porter and the stationmaster, who alerted police. The agents, two men and a woman, were found to have incompetently forged documents, wireless equipment and a Mauser pistol. Following a trial in London, the two men were executed, but the fate of the woman remains a mystery. The line closed in 1968, and now the bowling club occupies the old station site.

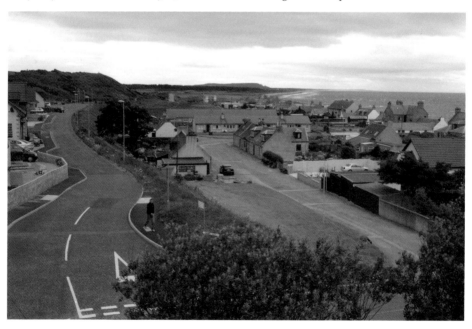

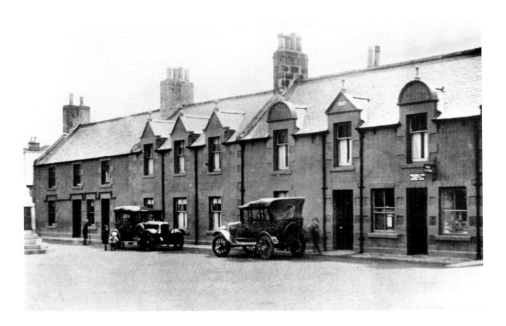

The Square, Portgordon

Portgordon – or Port Gordon, both being correct – was formed by the amalgamation of smaller communities, the western boundary marked by the Tannachy Burn. People from rural backgrounds came to settle in the developing village. Until the arrival of electricity in 1937, a man would light the paraffin street lamps every evening, and Portgordon was given the nickname 'Paraffin City'. The impact of the First World War on Portgordon was devastating, with the loss of many of the men who had volunteered for marine and naval service as well as the army. Afterwards, the village went into a decline. In 1921, the Duke of Richmond and Gordon travelled up from his Goodwood home to unveil the Portgordon War Memorial, sited in the village square.

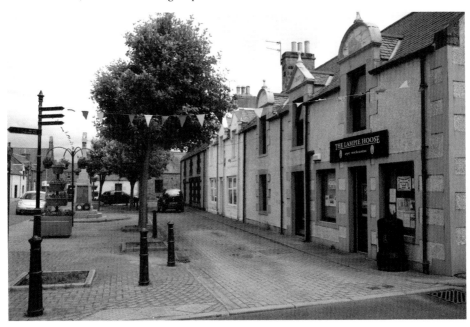

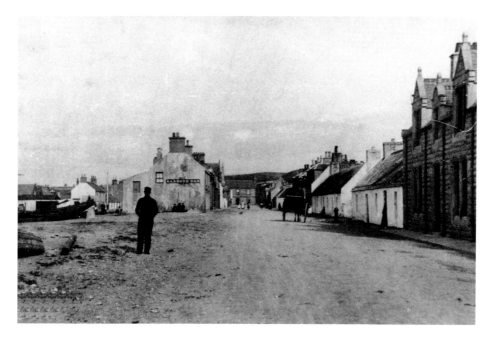

High Street Portgordon and the Constant Fishers

The general layout of this road has changed very little. In January 1953, a gale damaged the harbour and devastated Portgordon seafront. Houses were flooded, windows blown in, seawater rose to the height of the mantelpieces and about twenty families had to move out of their homes. The disaster did not deter the villagers from celebrating the Coronation in June with a procession, and lighting a bonfire as part of the celebratory coastal beacons. There was a series of nets for catching salmon between Portgordon and Tugnet to the west, some in front of Lennox Place until the middle of the twentieth century. Nowadays, the only constant fishing around Portgordon is carried out by the small resident seal community.

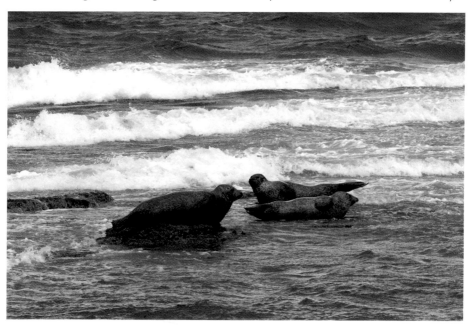

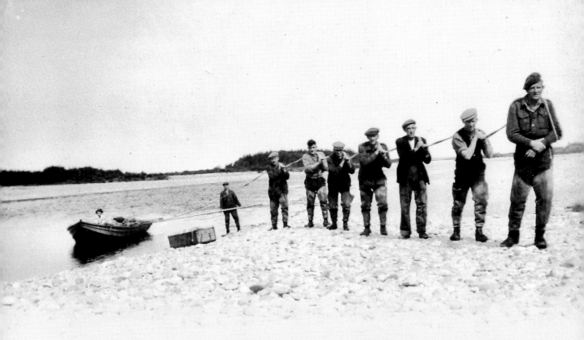

CHAPTER 3

Spey Bay to Lossie Forest

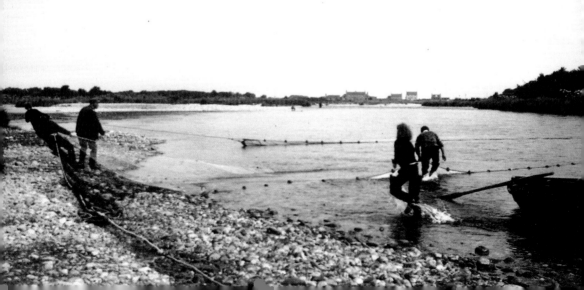

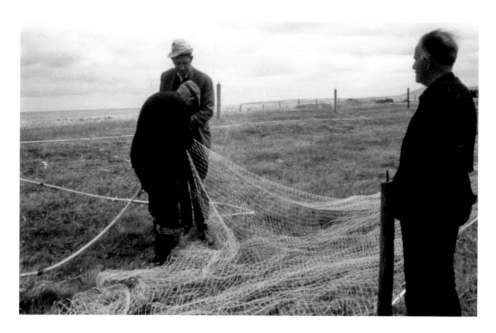

Moray Firth Fishers – Laying out the Nets, 1976: the Experts of 2010
For centuries, the Spey estuary was one of the most important Scottish salmon fishing areas. Between February and September, fish were caught as they migrated upstream to spawn – entering a maze of nets at high tide, they were trapped as the tide ebbed. A commercial fishing industry was developed in the eighteenth century at Tugnet by the Duke of Gordon, employing fishermen who continued this method of fishing into the mid-twentieth century. Sea-ducks and seals, dolphins, porpoises, gannets and ospreys are amongst the great variety of species that also enjoy fishing in the area. The firth is home to the world's most northerly population of bottlenose dolphins, and today generates several millions of pounds yearly in environmental tourism.

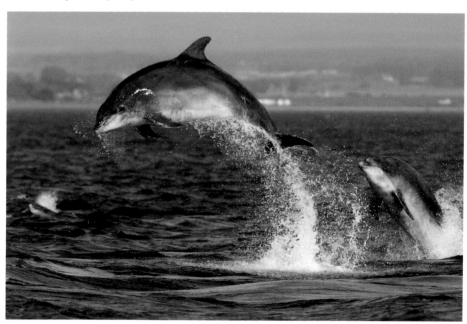

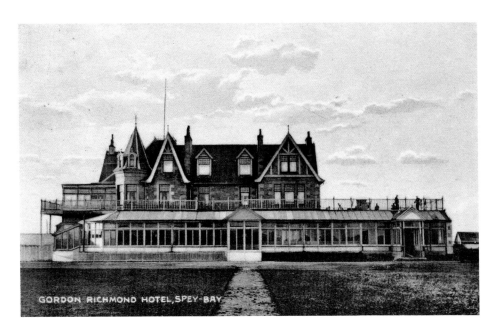

GORDON RICHMOND HOTEL, SPEY-BAY

The Richmond and Gordon Hotel in 1923 and the Area Today

The Richmond and Gordon Hotel was built at the east end of Spey Bay to accommodate the increasing number of visitors attracted by the fishing and the golf. The golf links were opened in 1907 by the Duke of Richmond and Gordon, watched by a crowd of around 3,000 people on a gloriously hot September day. The hotel was enlarged, and during the First World War was commissioned as a convalescent home for Belgian officers. During the Second World War it was requisitioned for personnel from nearby Dallachy airfield. The hotel burnt down in 1965; the coach-house – in the distant middle of today's picture – was rebuilt as the Spey Bay Hotel, but closed around 2006 and, along with the golf clubhouse, awaits redevelopment.

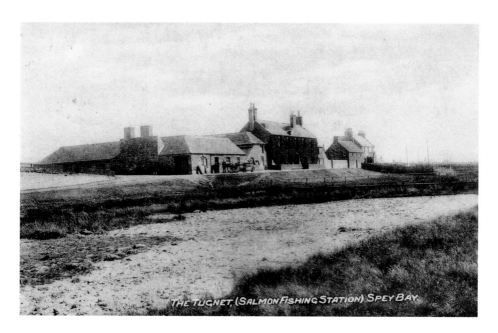

THE TUGNET (SALMON FISHING STATION) SPEY BAY.

Tugnet Fishing Station and Ice Houses

A commercial salmon fishing station, eventually employing 150 people, was built at Tugnet in 1768, the exported catches creating a considerable income for the Gordon estates. The icehouse, last used in 1968, replaced an earlier version and, with only a third showing above ground, is the largest in Scotland. Ice gathered from the Spey in winter was stored there, and the salmon kept fresh before being shipped out. The estate and fishing rights were taken over by the Crown Estates in 1939. The last salmon was landed at Tugnet in 1991. Since 1997 the fishing station has been converted into the informative Moray Firth Wildlife Centre, now part of the Whale and Dolphin Conservation Society, and includes a fishing museum and café.

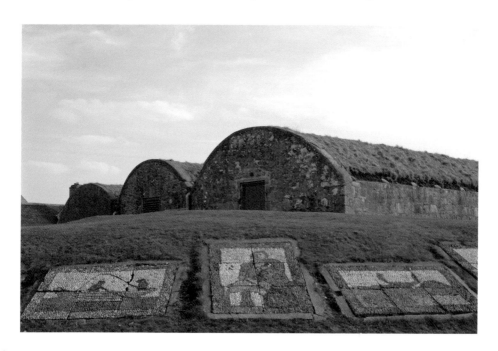

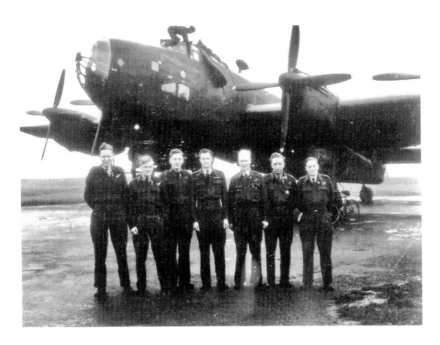

Dallachy

A mile inland, Dallachy airfield was built in 1942 – over 660 pilots were trained here in one year. Dallachy Strike Wing was formed in 1944 with the arrival of Beaufighter squadrons and Wellington bombers. The memorial built in 1992 is a reminder of the heavy losses sustained. The worst occurred on 9 February 1945; nine Beaufighters and a Mustang were shot down over Norway, and many more Beaufighters crashed on landing back at Dallachy on what became known as Black Friday. The mostly Canadian crew pictured by the Halifax – MZ 304 – died in November 1944 when their plane crashed into the sea near Kingston. All but one were buried in nearby Bellie churchyard – the youngest was nineteen years old.

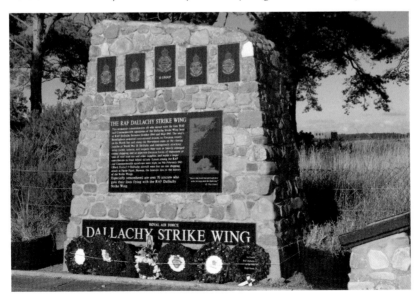

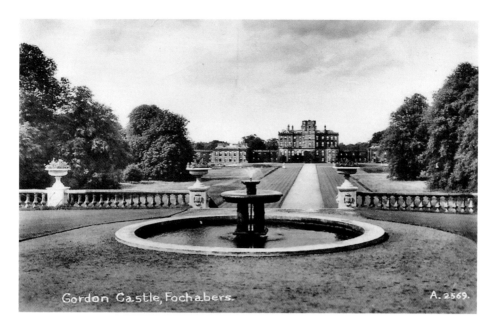

Gordon Castle, Fochabers. A. 2569.

Gordon Castle and Lands – Along the Spey to the Sea

The chequered history of Moray is firmly intertwined with that of the Dukes of Gordon. The original castle was built near the Spey crossing at the Bog o' Gight in 1479. Acquired by the Crown in 1936 in lieu of death duties, the castle was used as a VAD hospital during the First World War, and in the Second World War soldiers were billeted in the house and grounds. Returned to the family in 1950, two thirds of the building had to be demolished. The aerial view shows the rich lands of the Gordon estate as they follow the river to the estuary. The coastal area of the estuary, including floodplain and woodlands as far as Fochabers, is now a Site of Special Scientific Interest.

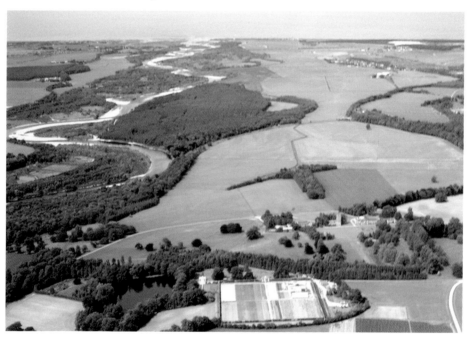

Crossing the Spey – the Bridge and the View

Bloody battles were fought over the ancient Spey crossings, but the site nearer Gordon Castle is long forgotten. Although the coastal railway line beyond Gordon Castle closed in the 1960s, the old steel-girder railway bridge still provides a well-used pedestrian link between Tugnet, Spey Bay and the westerly villages of Kingston and Garmouth. During the Second World War the Spey Bay area was out of bounds, cordoned off with defensive barbed wire, and mines were set. From the bridge the view stretches to Tugnet and the sea. Ospreys and otters fish here and nowadays, no longer the preserve of the wealthy, the area is a magnet for birdwatchers, fishermen, walkers and all who appreciate the varied wildlife and diversity of this constantly changing estuary.

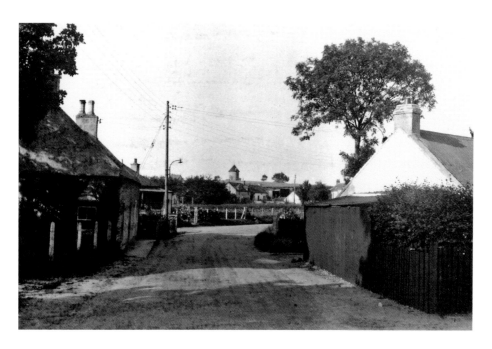

Station Road, Garmouth

Garmouth, the name probably from Gaelic, meaning a short narrow plain, was a significant port from the 1500s until the mid-1800s, despite the powerful Spey periodically destroying the harbour. Garmouth was still a seaport in 1650 when Charles II landed there on his return from exile in the Netherlands. After being carried ashore, he prudently agreed to sign the Solemn League and Covenant before travelling on to sanctuary at Gordon Castle. Overlooking stunning views from School Brae, the 1890s water-tower in the middle distance of both pictures stands beside standing stones which were erected around 1,500 BC. Station Road and the nearby viaduct crossing the Spey are the last of the Speymouth links with the busy railway era.

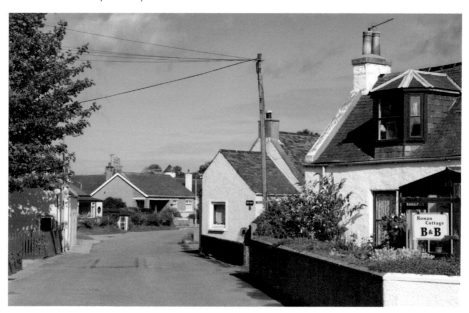

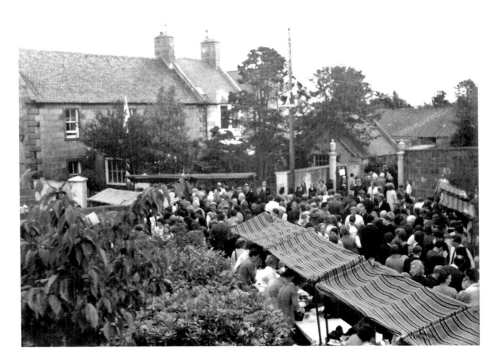

Maggie Fair, Garmouth

In 1587, Garmouth, on Speymouth's west bank, was made a Burgh of Barony, with the power of creating free burgesses, erecting a cross and a harbour and holding two annual fairs. Held at the end of June, Maggie Fair was originally named Margaret Fair, after the much-loved local benefactress Lady Margaret Ker, who married Sir James Innes in 1666. Nowadays, the festivities include working model steam engines and pipe bands as well as the traditional crowning of the Fair Maiden. The money raised by hardworking organisers goes to local charities. A plaque on the wall commemorating the 400th Maggie Fair marks the traditional site of the Fair. The War Memorial stands opposite, hidden by the hedge in the picture.

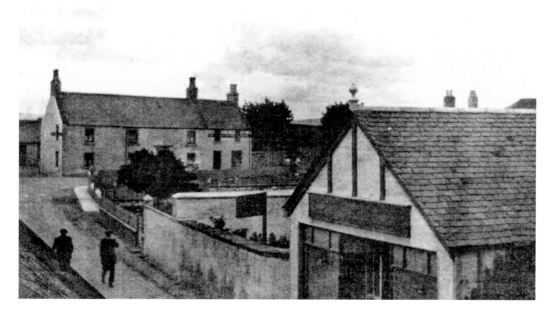

The Star Inn/Garmouth Hotel

Once the Star Inn, the Garmouth Hotel is the only survivor of several Garmouth inns, the old name still remaining on one window. Changed from an industrial complex into a residential area, new buildings now mingle with the old. Narrow winding lanes such as 'The Trochie' and 'The Wyndies' run between quaint cottages, which, despite simple clay and boulder construction, have survived for 300 years. Stone ballast from timber ships has been used as facing for some of the old buildings and black-earth ballast used in local gardens. Over the centuries the restless Spey has altered course, and its floods have destroyed many buildings – the most notorious being the 'Muckle Spate' of 1829, which caused much destruction and devastation.

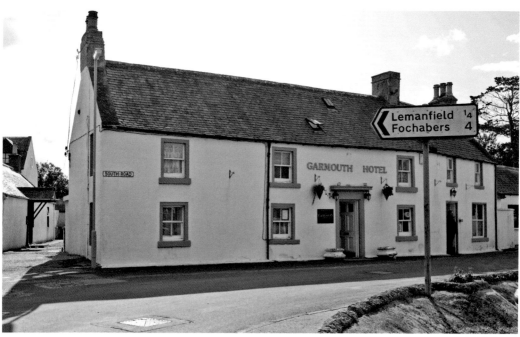

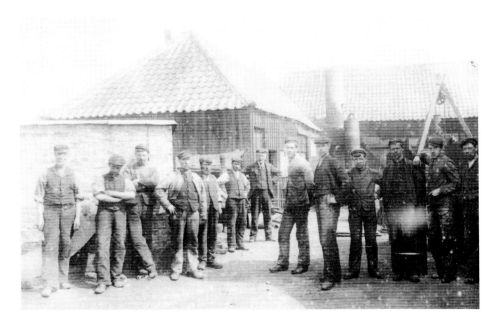

Duncan's Foundry, Garmouth

Shipbuilding began here in 1784, when two timber merchants from Kingston-upon-Hull set up business. They used pine logs, which had been felled from Glenmore forest and floated down the Spey, to begin a thriving shipbuilding industry which continued until 1908. Nowadays, hardly any trace remains of the busy Speymouth yards, sawmills, smithies and foundries. At least 533 vessels, with a total conservative estimate of over 83,000 tons, were launched from Speymouth yards. Duncan's Foundry was one of the many vital components of industrial Garmouth, but was replaced by a hall in 1906. Nearby, a house now stands beside the site of the old boat park. Some of the larger houses of the timber merchants, ship owners and captains still remain.

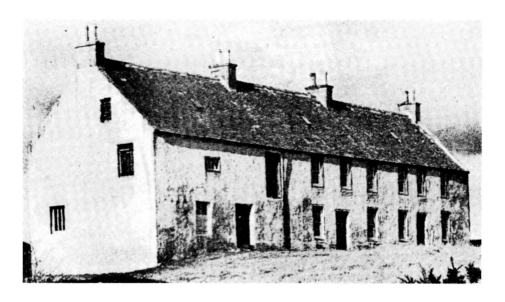

Dunfermline House, Garmouth

Now called Dunfermline House, the original building was supposedly constructed from stones taken from the nearby ruined Urquhart Priory, an offshoot of Dunfermline Abbey. Said to have originally been a fourteenth-century leper house, it was later enlarged. Built outside the village of Garmouth before the village of Kingston existed, it is now the only house in Kingston that is in Garmouth! Named Red Corff House – 'corff' being the name for a building used for boiling and curing salmon – it was used as such until acquired in 1783 by the timber merchants who began the shipbuilding industry of Speymouth. The busy port exported grain and timber, but due to the constantly shifting river, had no stone built quays or breakwaters.

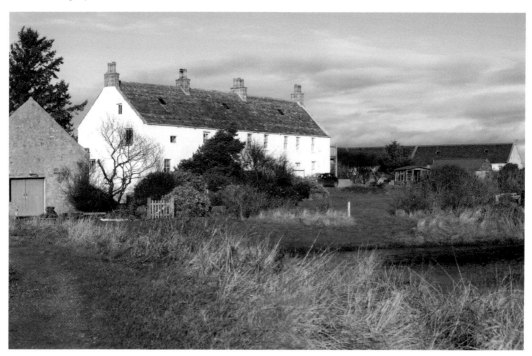

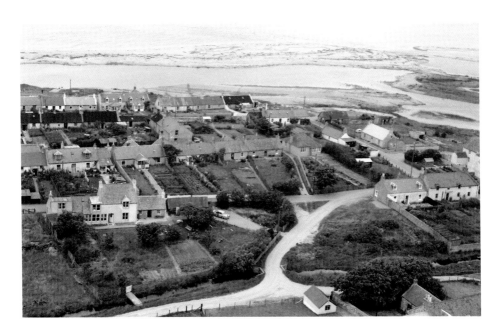

Looking Down on Garmouth

The modern picture from Kingston Brae shows distant Bin Hill, with Tugnet far left. From the early 1600s, great pine forests below the Cairngorm Mountains – Abernethy and Glenmore – supplied vast quantities of valuable timber. Log rafts were floated 40 miles down the River Spey – hard and dangerous work for men steering and riding on them. At journey's end, the men would stay the night at a Speymouth bothy before walking back to the start of their journey. Uses for Abernethy pine included ships' masts, pit-props, water pipes, charcoal for iron smelters and, eventually, railway sleepers. For two centuries, Speymouth was the premier British timber exporter. Transport methods changed with the advent of the steam railway to Abernethy in 1863.

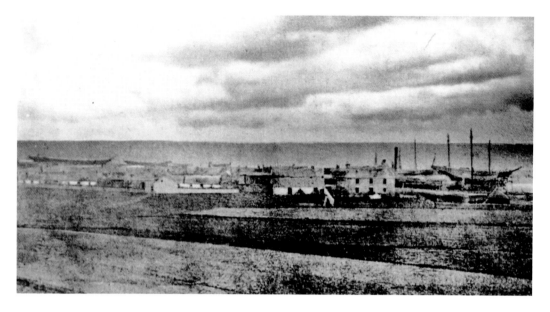

Kingston-upon-Spey

The old 1870s picture shows a number of large wooden ships at the busy Kingston Port. Shipbuilding began here in 1785, and 'Spey-built' became a byword for quality ships which sailed all around the world. The first to be built was a 110-ton brig, the *Glenmore*, and the last wooden schooner was launched in 1890. Building of steam drifters continued until 1906. There were inevitable industrial accidents. Some ships were wrecked in the river mouth, and at exceptionally low tide their old timbers are still visible. Throughout the centuries, the area has always been subjected to flooding and several attempts have been made to control the shifting shingle banks and the constantly-changing river mouth.

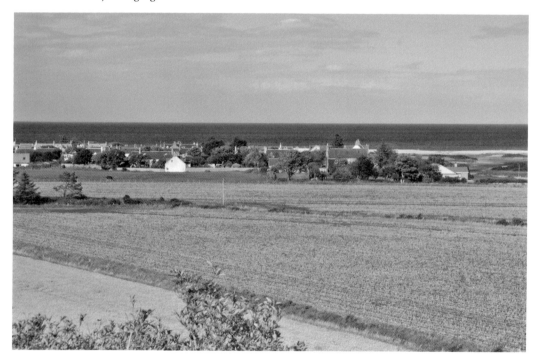

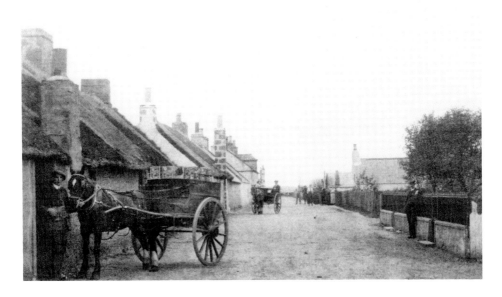

Beach Road, Kingston

In 1784, two timber merchants from Kingston-upon-Hull set up shipyards and sawmills, employing mostly local labour, and naming the new development Kingston-on-Spey after their home town. The eventual seven shipyards here launched many schooners, as well as 1,000-ton East Indiamen which sailed the world's oceans. Kingston still retains rows of shipwrights' houses, and those of wealthier owners, merchants and captains. The twin villages of Garmouth and Kingston no longer ring with the noises from the shipyards and sawmills, harbours have vanished and the waters of Spey Bay are no longer busy with cargo-laden ships. A more recent pre-cast concrete works has been replaced by a nature reserve at the Lein, to the west of Kingston.

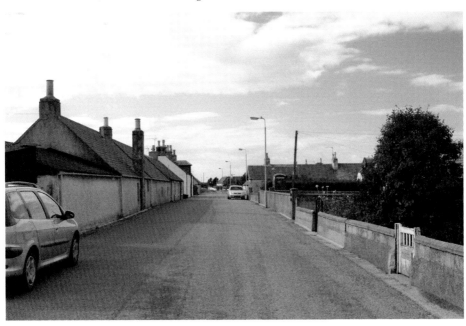

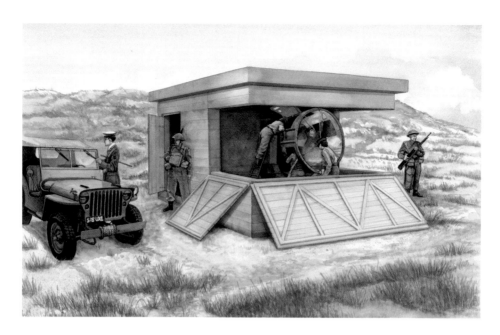

Lossie Forest War Defences

The long stretch of Innes Links between Kingston and Lossiemouth, once sand dunes and shingle, is now covered with conifer forest. In May 1941 the Polish Army Engineer Corps constructed some of the coastal defences, providing protection along the vulnerable coastline with anti-tank barricades. In Lossie Forest two gun emplacements remain, once armed with old First World War naval guns. Machine gun emplacements protected the coast and Lossiemouth port, and calculations for aiming and firing the big guns were made in the Battery Observation Post until radar was introduced. There were also two searchlight stations. Operations ceased in 1945, and the guns were removed. Anti-tank blocks still run through the forest, along with square or hexagonal pillboxes which were often manned by the Home Guard.

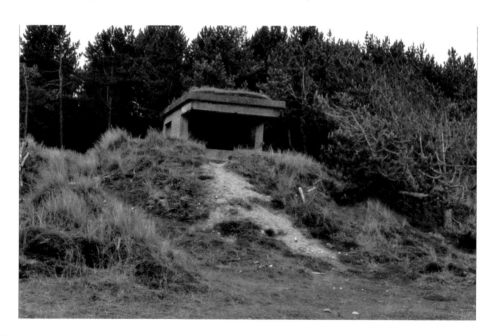

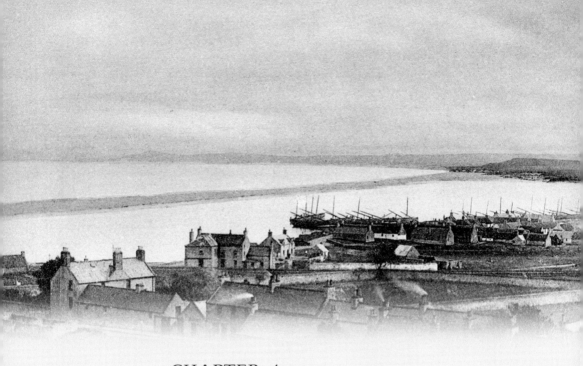

CHAPTER 4

Seatown, Lossiemouth
& Covesea

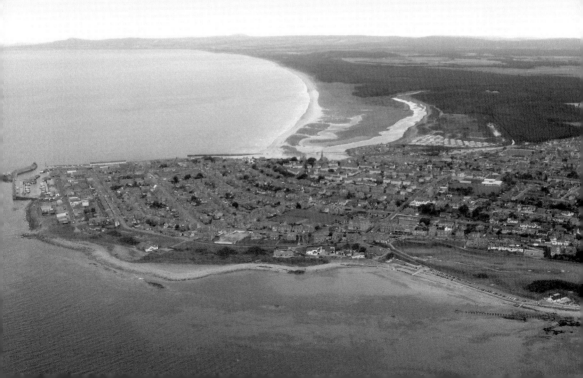

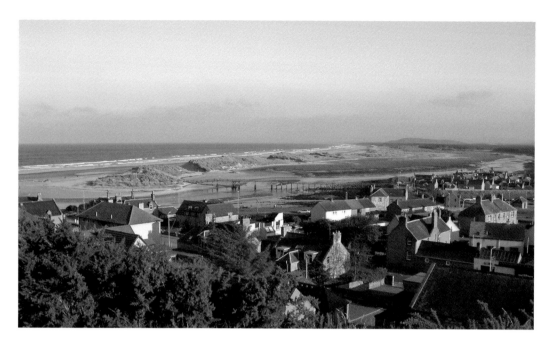

Looking West over Seatown from Coulardhill

A thousand years ago, the mouth of the Lossie was three miles inland and cargo ships could sail to Spynie Palace. When the port at Spynie was no longer viable, the Elgin town council bought land in 1698 and established a new village at Seatown. With gable-ends to the sea, the fishermen's cottages of Seatown are now protected by sand dunes created in the early 1900s by using old railway carriages. The original mid-nineteenth century wooden footbridge across the river had a middle section which lifted to allow fishing boats access to Seatown. A replacement bridge was built in 1908. By the eighteenth century, the later settlement of Lossiemouth had become the trading outlet for Elgin and the Continent.

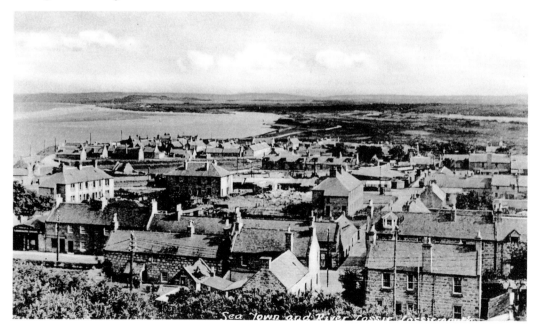

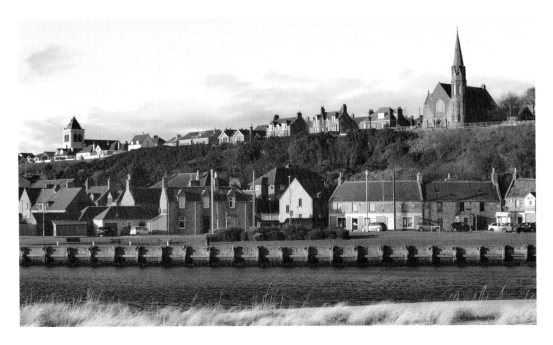

Prospect Terrace from Seatown and The Hillocks

In 1909, J. Ramsey Macdonald (later Prime Minister) built 'The Hillocks' in Moray Street when refused permission to build on his preferred site on Prospect Terrace, overlooking Seatown and the East Beach. The glorious seven-mile East Beach is accessed from Seatown by the wooden bridge. Fishermen once beached their boats on the river shore and were called 'dogwallers' from their habit of drying dog skins on the walls before using them as floats. The new village and harbour of Lossiemouth was laid out in 1764 and later Branderburgh, built around St James Square, expanded until, by 1890, it had merged with Stotfield, forming today's Lossiemouth. The two church towers of St Gerardine and St James make a distinctive skyline.

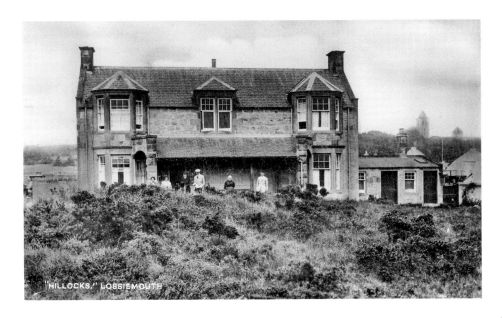

"HILLOCKS," LOSSIEMOUTH

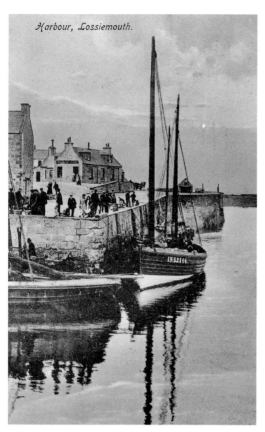

Harbour, Lossiemouth.

East Harbour

The town of Lossiemouth grew and the harbour became busier, eventually becoming inadequate and ruinous. In 1837 Colonel Brander of Pitgaveny helped develop the new harbour at Stotfield Point, laying the foundation stone in 1837. The harbour at Stotfield soon became the centre of the new herring fishing fleet. At the same time, Colonel Brander also developed Branderburgh village around St James Square. His was the first house there in 1830 – this eventually became the Brander Arms inn. Next to it, the first Lossie lifeboat station was established in 1859, the shed being replaced in 1899. When the fishing fleet was in harbour, it was difficult to launch the lifeboat and, in 1923, the lifeboat station moved to Buckie. In 1932, in a dispute with the council, the Pitgavney laird ploughed up the square. Nowadays commemorative plaques, tributes to past achievements of local folk, are displayed there.

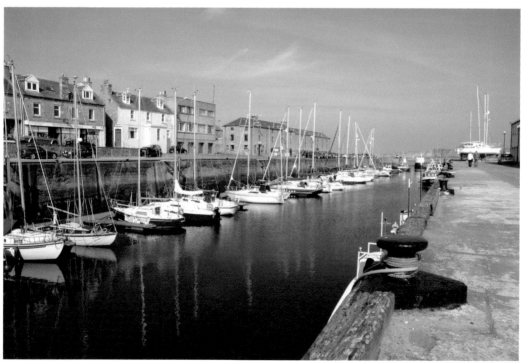

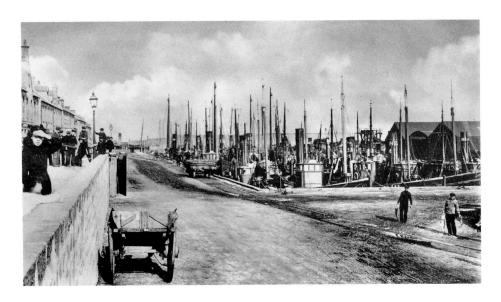

Lossie Harbour – From Work to Play

As the fishing fleet expanded, the harbour was enlarged, enabling bigger boats to berth and encouraging more fisher families to move to Lossiemouth. Harbour improvements were also required to accommodate larger cargo and passenger-carrying steam boats. The challenging harbour entrance was due to a formation named Maggie Duncan Hole after the first boat wrecked there; some claim this hazard was worsened by later pier extensions. In the mid-twentieth century, over ninety fishing boats would lie in the harbour and folk would go to watch the fleet sail. Nowadays only a couple of local fishing boats are allowed in the seventy-eight-berth marina, pleasure boats pay the harbour dues and the quayside sheds have been replaced by modern flats.

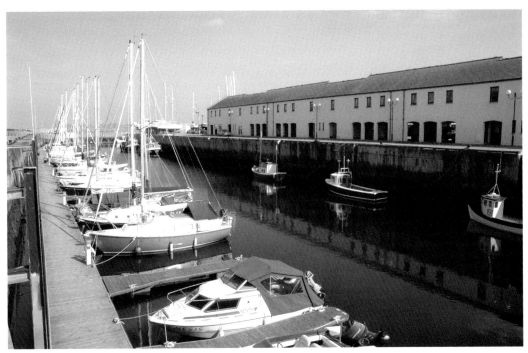

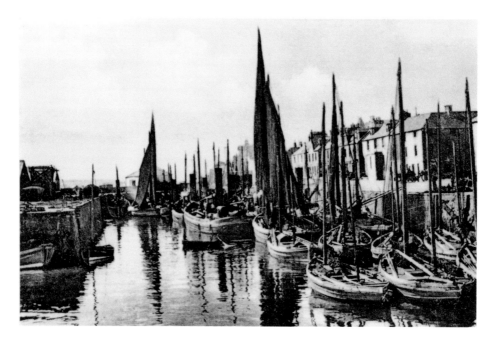

Lossie Harbour – Changes over Ninety Years

Once busy dealing with the requirements of fishing boats – 'fifies', 'scaffies', 'zulus' and the later steam drifters – some of the old harbour buildings overlooking Lossiemouth marina have now been converted to shops and cafés. There is also a fascinating fishing museum, which gives an insight into the constant dangers and challenging hardships endured by fisherfolk throughout the years. Many wrecks lie outside the harbour, and storm damage has required several repairs. Fishermen faced danger, their wives endured hard work baiting lines and mending nets and they would walk as far as Aberlour to sell fish or barter their wares for vegetables and eggs, or wood chippings used for smoking fish. The advent of the train made their journeys much easier.

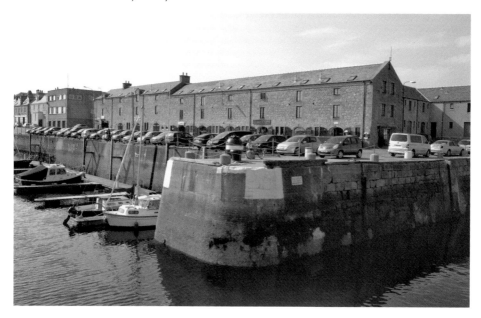

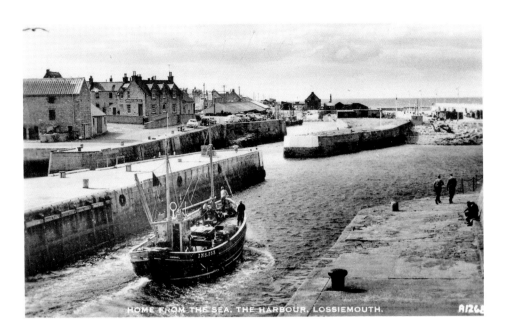

HOME FROM THE SEA, THE HARBOUR, LOSSIEMOUTH.

Looking West Towards the Fish Market and Old Slip, Lossie Harbour

In 1879 the first zulu-class fishing boat – the *Nonesuch* – was built here. It proved a superior design until the 1920s, when John Campbell of Lossiemouth designed the first modern seine-net fishing boat. After the Second World War, Lossie fishermen began exporting prawns – a very lucrative trade when pub lunches became more popular. Records from 1847 show exports from Lossiemouth harbour included grain, barrels of herring, cod fish, timber and livestock. Imports were mainly foreign merchant goods and English coal for domestic homes and for distilleries, lime kilns, brickworks and local breweries. There was also a lively trade in passengers on the steam packets from Leith and London. Fish auctions took place in the open air until 1934, when the covered market was built.

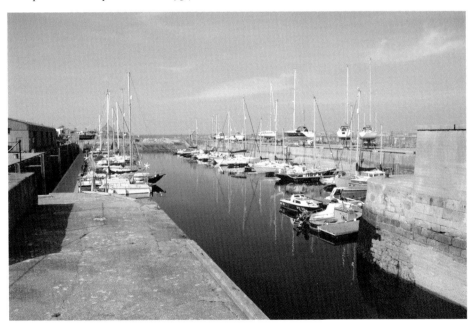

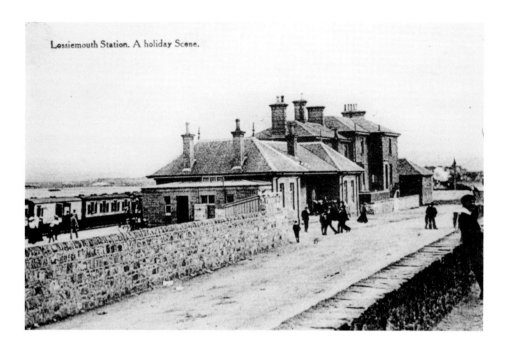

Lossiemouth Station. A holiday Scene.

The Railway and Recreation

Saint Gerardine inhabited a cave near here, shining a light to warn ships of deadly rocks nearby. His cave was vandalised in the 1780s and the remains cleared to make way for the railway station. In 1852, Lossie to Elgin was first railway north of Aberdeen, the carriages and locomotives shipped by sea and assembled at Lossiemouth quayside. There was a turntable for the train at the harbour and the Station Hotel opened in 1864. The harbour was extended south and imported goods, including cheap coal, could be taken to Elgin and grain exported. In 1868, high seas cast a 5-foot shark onto the rail track! The railway was axed in 1964 and a recreation area now occupies the site.

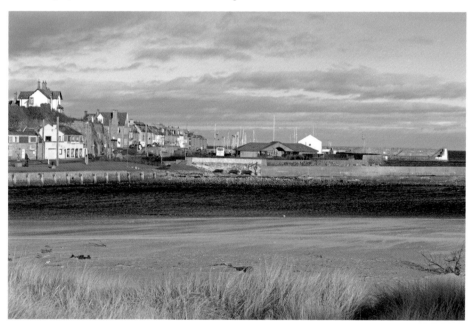

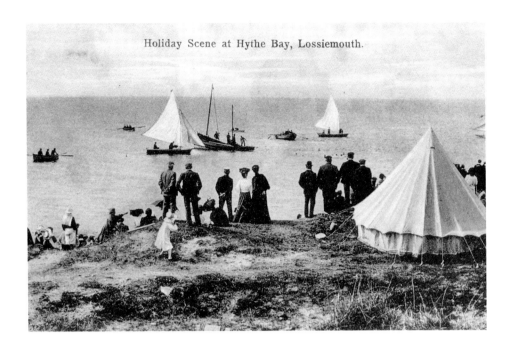

Holiday Scene at Hythe Bay, Lossiemouth.

Hythe Bay

Shell mounds and ancient kitchen middens revealed the presence of ancient man here. Sailing has been a popular activity since Victorian times – the Lossiemouth sailing club now lies below the golf clubhouse. Regular train excursions to the town in the summer once carried over 2,000 passengers at a time, and hotels like the Stotfield and the Marine were built to cater for the tourists' needs. Branderburgh public baths opened in 1874, pumping in sea water which was warmed by a steam pump to the 50 feet by 25 feet pool and the six private, carpeted bathrooms. The Beach Bar now occupies that site. Between the world wars, motorcycle races at up to 90 mph took place along the beaches.

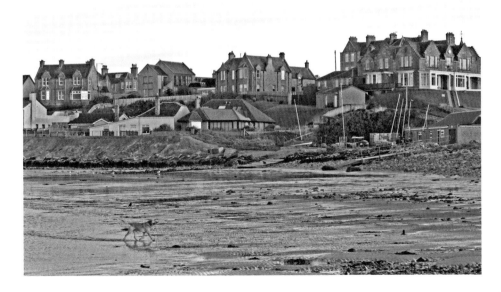

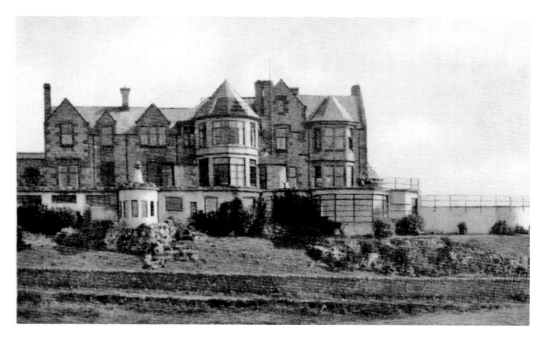

St John's Hospice, Skerrybrae

Originally the home of Major Boyd Anderson – a mischievous, wealthy and very generous local benefactor who died in 1972 – Skerrybrae contained a swimming pool which was filled by the high tide and emptied when the tide ebbed. On moving to Edinburgh in 1957, the Major gifted the house to the Order of St John of Jerusalem. It was converted into a convalescent home – the Hospice of St John. In 1979 it changed hands, opening as the Skerrybrae Hotel. In the eighteenth century, silver and lead mines were opened in Lossiemouth, but after several attempts they were found to be commercially unviable. All traces were demolished by 1897, including the chimney stack – once a distinctive landmark for fishermen.

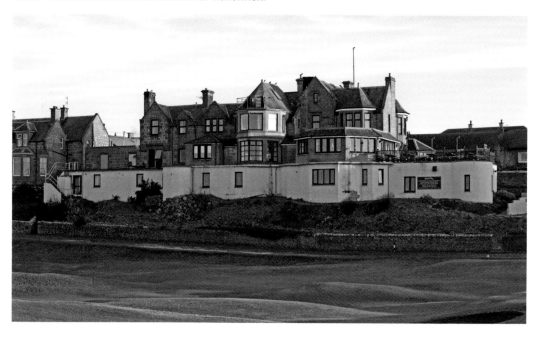

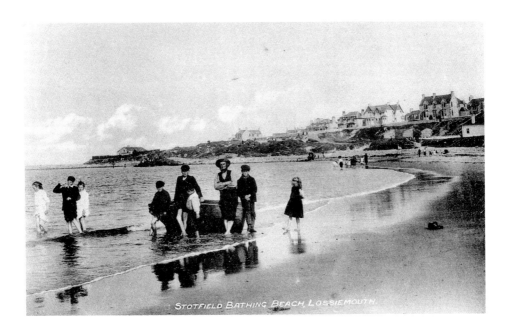

STOTFIELD BATHING BEACH, LOSSIEMOUTH.

Stotfield Beach – Looking East

In the Middle Ages Stotfield was mainly a farming settlement, but gradually fishing became the predominant activity. In 1670, skippers of Stotfield were recorded 'idolatrously' carrying lighted torches around their boats on New Year's Eve. On 25 December 1806, twenty-one fishermen from Stotfield perished in a storm, leaving seventeen widows and fifty-seven orphaned children. Stotfield ceased to be an effective fishing village, the only remains of it now being Paradise Row. Stotfield beach became a popular bathing beach; a pole was erected to mark the 'Ladies only' area, and between 10 a.m. and 2 p.m. a policeman guarded their privacy. A storm in 1953 wrecked all the beach huts, but remnants of war-time coastal defences remain.

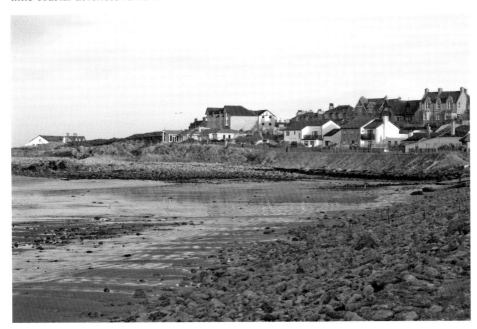

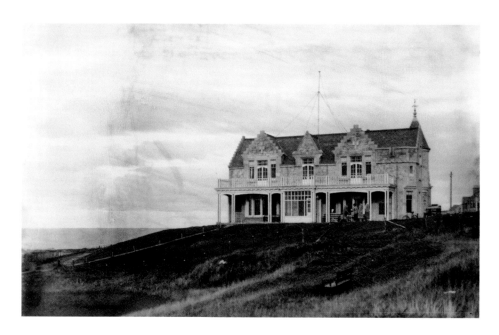

Moray Golf Club and the View From the Clubhouse, Lossiemouth

Moray Golf Club, considered one of the finest in the area, helped promote Lossiemouth as a tourist destination. It opened in 1893, expanding gradually, until by 1980 it had grown from the original six-hole course into two eighteen-hole courses. It was here that members suspended pacifist Ramsay Macdonald's membership in 1916 – a decision later regretted! A plaque on the course commemorates the conspicuous bravery of two past caddies, George Edwards, DSO and his brother Alexander Edwards, VC, who both served in the Seaforth Highlanders, sacrificing their lives in the First World War. Today, overlooking the Moray Firth with Tornadoes flying overhead, stands 'Hamish', created by sculptor Andy Scott. Ten-year-old Hamish once travelled to Murrayfield to support the Scottish rugby team!

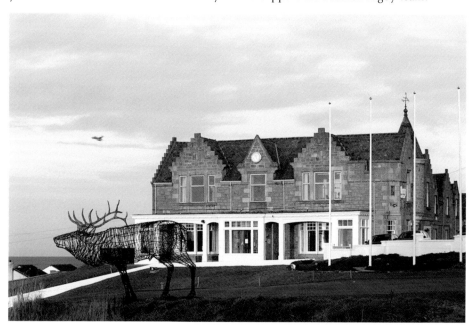

Looking Along the West Beach Towards Covesea Lighthouse

Until the early twentieth century the caves around Lossiemouth and Covesea have been home to many itinerant folk, some families living for years in these rough shelters. Pictish carvings are incised on the walls of one – the Sculptor's cave – which has revealed a wealth of archaeological material dating back thousands of years. In more recent times, Lossiemouth youngsters enjoyed informal dances in some of the caves nearer the town. In the new photograph, flying over the West Beach, a Tornado prepares to land at Lossiemouth airfield. Constructed in 1938, the RAF airbase was taken over by RNAS in 1946 until 1972, when it was handed back to the RAF. Shackletons, Harriers and Tornadoes were some of those flown from Lossiemouth. The Navy, and more recently the RAF, presence has contributed greatly to the local community, many forces personnel sagely choosing to settle in Moray on their retirement.

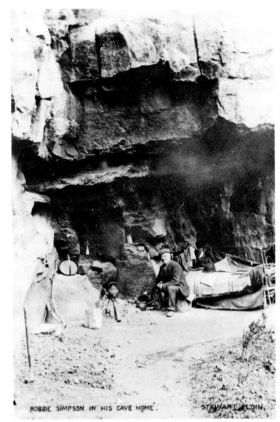

ROBBIE SIMPSON IN HIS CAVE HOME. STEWART ELGIN.

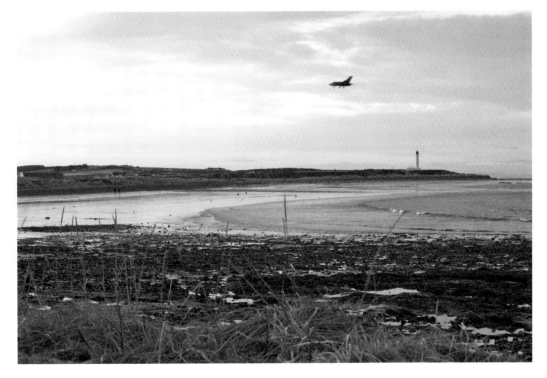

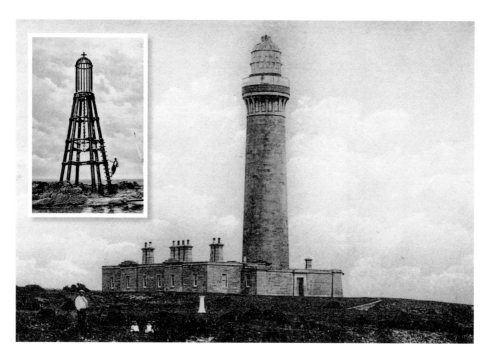

Covesea Lighthouse and the Skerries Beacon

Following a storm in the Moray Firth in November 1826, when sixteen vessels were sunk, petitions were submitted for a lighthouse at Covesea Skerries. A beacon was erected on the skerries in 1844, and the lighthouse, designed by Alan Stevenson, was eventually built in 1846. Local landscape artist David West, who spent some time in the Klondike gold rush, is pictured on the beacon. Originally, the lighthouse lens was rotated by a clockwork mechanism with gradually descending weights providing the energy. In 1984, it was automated, remotely controlled from the Northern Lighthouse Board's offices in Edinburgh. The original lens is now on display at the Lossiemouth Fisheries and Community Museum. Nowadays the lighthouse keeper's cottages are used for holiday accommodation.

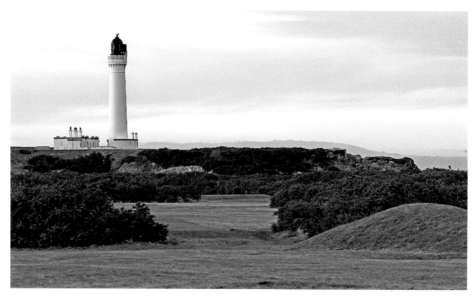

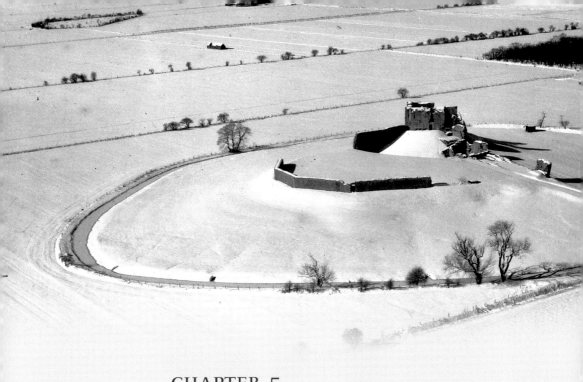

CHAPTER 5

Duffus, Clashach, Hopeman & Burghead

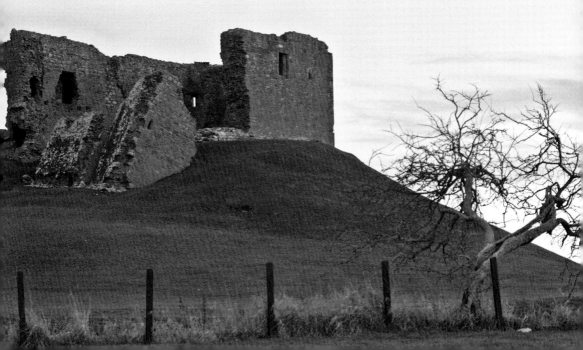

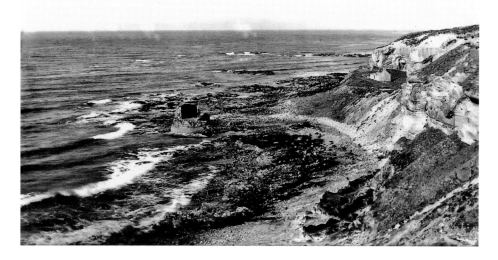

Clashach Quarry

On the cliffs a mile from the ruins of Duffus castle, quarries provided stone for Dornoch and Elgin cathedrals, and local harbours. Stone was mainly transported by sea on sailing schooners loaded from the small Clashach harbour. Two rocks to the east are named Nell and Jane, after one schooner that foundered and was wrecked when coming into harbour. The harbourmaster's house can be seen in the old photograph. The footprints of dinosaurs are preserved here, the remains of a hermit's cave lie nearby and the mysterious Lady in Red is said to haunt the area. More recently, local sandstone was used for hydroelectric schemes, the Forth Road Bridge, the new Edinburgh museum, Oslo town hall and Barcelona cathedral.

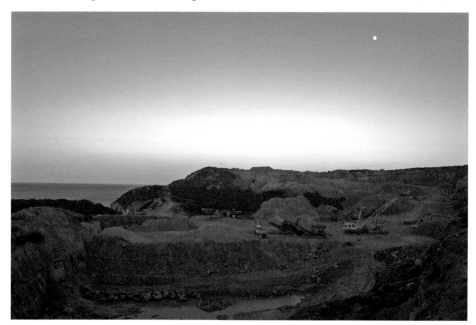

Hopeman Railway

In 1810, Inverugie lime works were developed and what was possibly the first rail track in Scotland transported lime to Hopeman harbour. A spur from the Aberdeen–Inverness railway line came from Alves to Hopeman in 1892, with passengers services until 1931. The line split at Hopeman, the north track, the Lorrimans, collecting cargo from farms and local industry. The final freight service closed in 1957. Quarry operations transferred from Clashach to Greenbrae quarry, where there was a small siding with a crane for unloading. Local stone was used to build a short-lived four-storey flour mill which, in 1851, was driven by a steam engine. Converted into flats, this building is now named Lancaster Court. Quarrying reverted to Clashach in the 1970s.

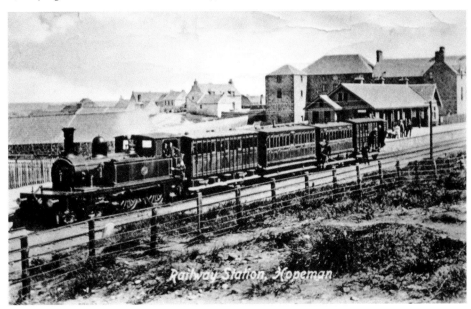

Railway Station, Hopeman

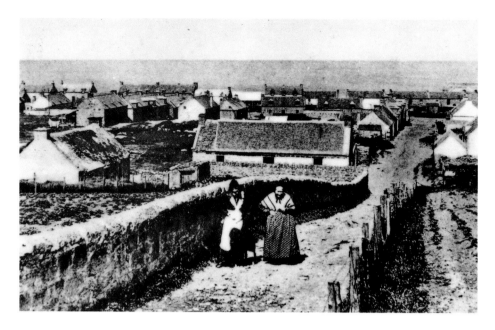

Old Routes Leading to the Harbour

A small community existed here before Hopeman was founded as a quarrying and fishing village in 1805. The name probably derives from the French 'Haut Mont' – the high hill, referring to nearby Tappoch of Roseisle. This was a landmark for smugglers, who landed cargoes on a large rock – the Collach pier – a convenient jetty for unloading wine and brandies onto ponies before returning to France with wool and other cargoes. Caves around nearby Cummingston were handy for hiding contraband. Separate wells were used by fisherfolk and crofters, the fisherfolk using the once-holy well of Braemou. Eventually, water was supplied from a nearby reservoir, the water pumped there by a windmill from a well until the mains supply was connected.

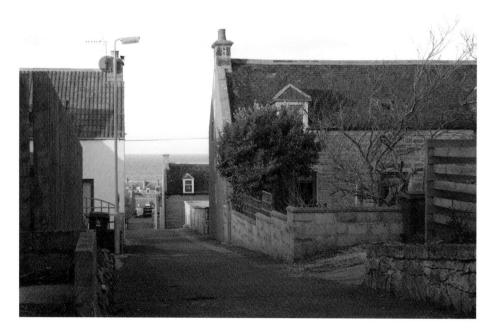

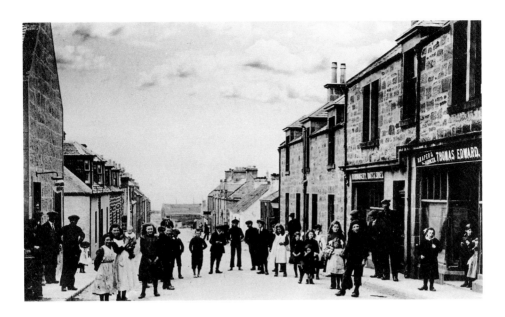

Harbour Street, Hopeman

In 1840 a new harbour, built from local stone, was opened, and for a time was more important than Lossiemouth or Burghead. Feeing markets were held in order to get enough men for the fishing fleet. By 1888, over 130 boats were fishing very successfully from Hopeman, employing more than 350 men and boys. Large quantities of haddock were cured and sold to Aberdeen. The village developed rapidly, and eventually five fish-curing businesses were in operation. Women worked as gutters in the fish sheds and coopers were employed making barrels which, when filled, would pile up along Harbour Street awaiting loading. The now-restored Ice House by the bridge at Harbour Street was last used in the early 1900s.

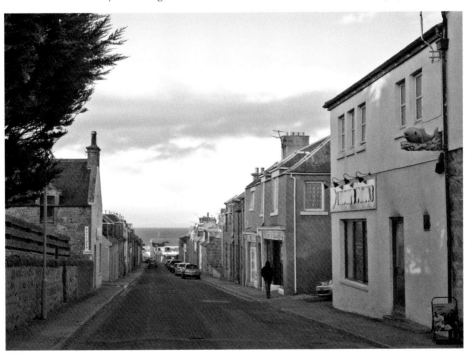

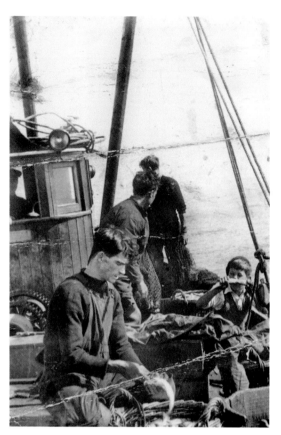

A Hopeman Boat in 1932, and Hopeman Harbour Today

When originally built in the early nineteenth century, Hopeman harbour was the only good one between Buchan Ness and Inverness. It attracted fisherfolk from Avoch, Cromarty and Campbeltown to settle, with some families claiming to have fled from the Ardersier area following the Highland Clearances. Some boats worked the lines in home waters, but many Hopeman boats went away with the fleet during the herring season. The men worked hard, and so did the Hopeman girls. Many local girls joined the bands of fisher lasses, following the fleet to gut and pack the herring around the coast from Stornoway to Yarmouth and earning an independence which was rare for young women in those days. Despite 1891 harbour improvements, the gutting girls had to haul the fleet out through the north end of the harbour in 1900, and the constant silting proved a problem. Hopeman is now a recreational harbour.

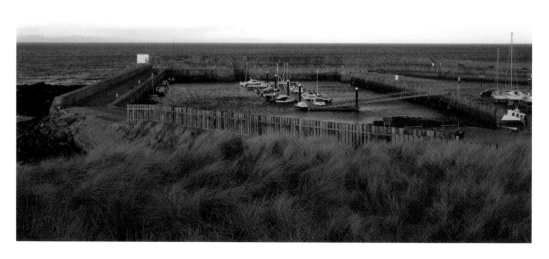

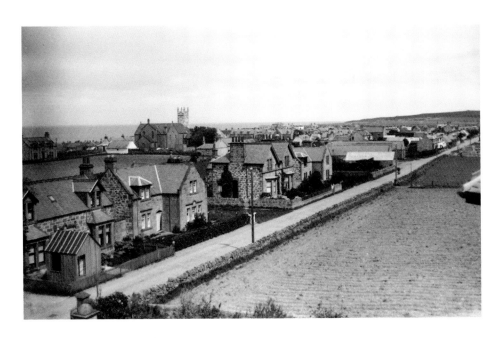

Hopeman From the South

The first houses in Hopeman were simple, single-storey dwellings with thatched roofs. With wealth accrued from the fishing, and the consequent growth of the village with many associated industries, there was a dramatic improvement in housing standards. As there was no public coast road from Hopeman, it was once necessary go past Duffus Castle and enter Lossiemouth by Kinneddar, near the site of the old graveyard and ancient, but long vanished, castle. When the airfield was built on farmland the route was more circuitous, going near Elgin. The public roads were developed after the Second World War. Prime Minister Herbert Asquith spent a holiday at Hopeman Lodge in 1913, and enjoyed beating Ramsay Macdonald at golf – despite being threatened by suffragettes at Lossiemouth.

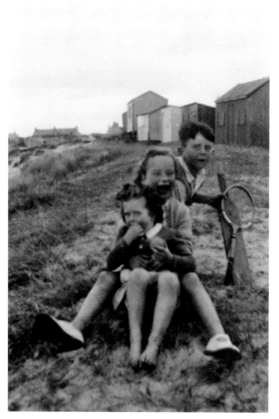

Hopeman At Play – the Famous Beach Huts

With four white, gently shelving beaches ideal for swimming and hauling boats out of the water, Hopeman is a popular holiday resort. Aberlour Children's home used the house known as The Neuk as a holiday home for many years until 1968, as did other groups with special needs. Hopeman Lodge overlooks the East Beach. There, the splendidly painted beach huts which sprung up in the 1800s are inherited through local families and are carefully preserved and treasured. After opening in 1900, with an old railway carriage used as a clubhouse, the nearby golf course survived the Second World War thanks to the efforts of a few determined locals. Between Hopeman and Burghead lies Cummingston, which was also founded in 1805; the houses are named not numbered, and most enjoy a view over the Moray Firth. Primroses cloak the cliffs in spring and nearby rocks provide a challenging training venue for climbers.

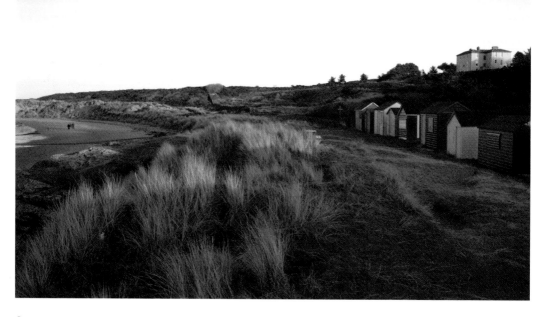

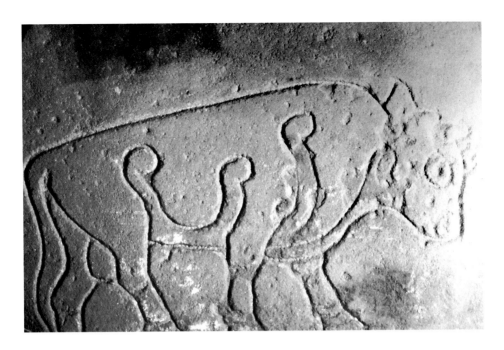

Ancient Burghead

A Pictish promontory fort, Burghead was the biggest Iron-Age fort in Britain. Possibly known to the Romans who had proven contact with nearby Birnie, Burghead was once called Torridun. After capture by the Norsemen in the ninth century it was known as Burghe, or the Broch. Unique to Scotland, the misnamed 'Roman' well on the site was cut out of solid rock, with twenty steps leading down into a 5 metre square vaulted chamber; the pool is still fed by an underground spring. The bull carving is one of thirty found, and is thought to have been displayed around the 8 metre thick ramparts. The Burghead radio transmitter station was erected in 1936 and was the most northerly radio transmitter of the time.

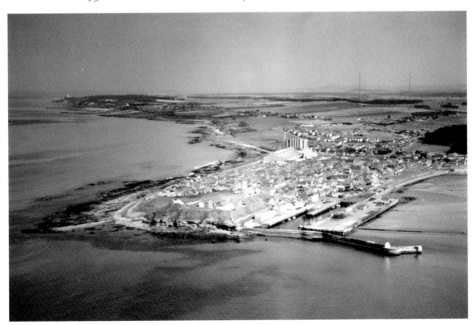

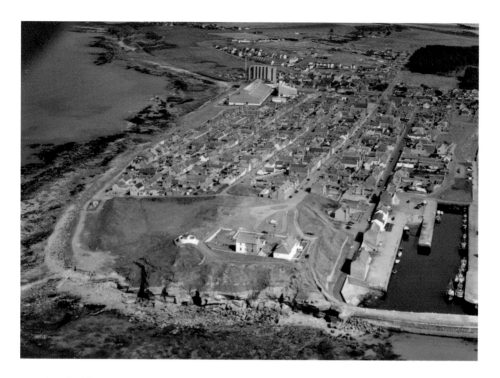

Burghead Village and Harbour

Every 11 January – the date of the old New Year's Eve – the ancient fire ceremony is observed. A blazing barrel of Archangel tar is carried by the 'Clavie king' around the harbour and the village, driving out the spirits of the old year and culminating in the blazing 'Clavie' being set up on a pillar on Doorie Hill, next to the old fort ramparts. The large building – Burghead Maltings – has supplied vast quantities of malted barley to the whisky industry since the 1960s. The schooner pictured, *Prince Louis*, was built in 1944 and acquired in 1955 by the Outward Bounds Trust. Berthed at Burghead, she was used for training in seamanship by pupils of nearby Gordonstoun School until 1968.

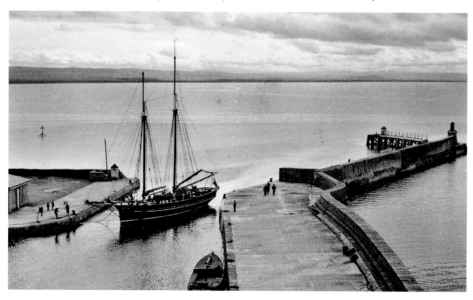

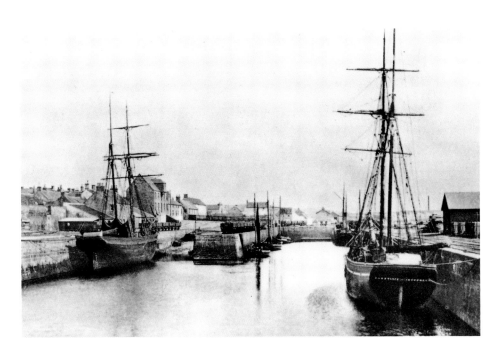

Burghead Harbour – 1900 and 2010

Thomas Telford designed rock-hewn Burghead harbour and the imposing granary buildings (now flats), built in 1809. Most of the ruined fort was obliterated during construction of the new village in 1805, stones from the levelled outer ramparts being used to build the new harbour. Burghead became a port of call for many steamers, although until 1840 goods and passengers had to unload offshore until a steamer pier was built. Steamer service survived until the railway arrived in 1863. The railway eventually became unprofitable and closed to passengers in 1931. By the 1930s there were 400 ships trading annually including to Leith, Aberdeen, London and also the Baltic. Some Burghead gardens contain Russian soil, which was once brought in as ballast.

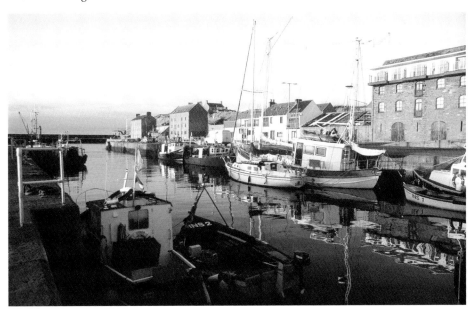

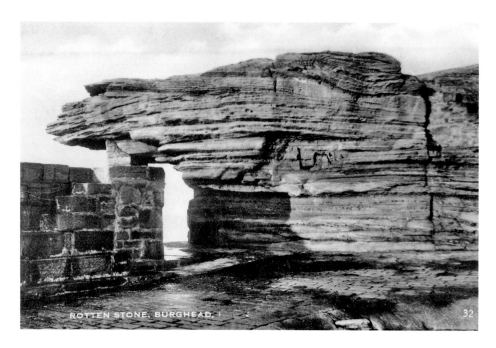

ROTTEN STONE, BURGHEAD. 32

The Rotten Stone

The Rotten stone, and those surrounding it, are proof of the many changes over millennia. These rocks are a preserved river bed, formed when the Moray landmass lay near the Equator. Unaware of its origins, the Burghead fishermen made use of its pumice-like qualities. The haphazard old settlement, with its fisher houses thatched with heather, underwent great changes with the building of the new village, the harbour, salmon fishing, the herring boom and the industrial revolution. For a few years chemical works, established in 1864, manufactured naptha, sulphate of ammonia, gases, coal tar, torch oil, varnish and asphalt, the smell being 'worse than gasworks'. A visitor centre now occupies the old coastguard lookout and gives a good display of local history.

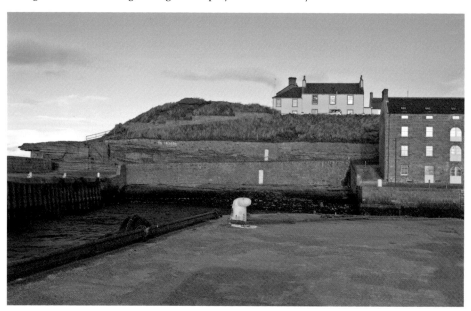

Roseisle, Kinloss, Findhorn & Culbin

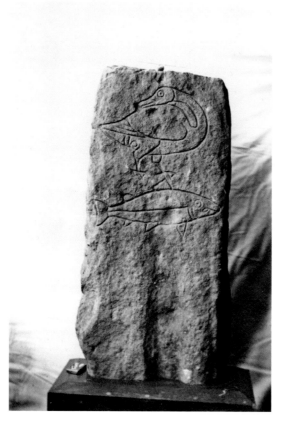

Mysteries and Magic of Roseisle

Once called the Warly (Warlock) Hill, the distinctive Tappoch of Roseisle marks an area rich in ancient mysteries. On the edge of the once-extensive Spynie Loch, it is just a short distance from the massive ancient promontory fort of Burghead. Neolithic pottery and cist graves, stones with cup and ring marks, Pictish carved stones, runic inscriptions, mass graves at a nearby ancient battle site, and recently discovered medieval treasures in the area all await modern archaeological investigation and assessment. Pictured on the far left of the complex below, the new distillery opened in 2010, adjoining the Roseisle Maltings. A representation of the Roseisle Pictish stone guards the entrance. Aiming to be as environmentally sustainable as possible, the distillery uses a natural underground water supply and the produce of the maltings. Whisky output is estimated at 12.5 million litres a year; the first casks will be ready for blending in 2012.

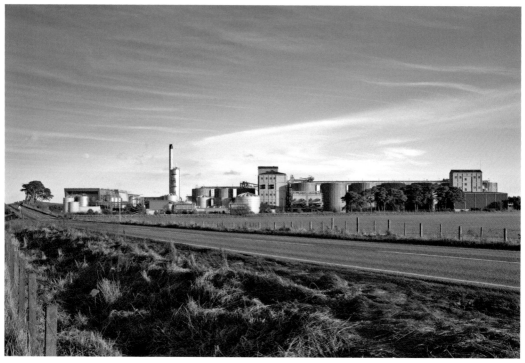

Kinloss Abbey in War and Peace

The 1868 sketch shows the ruined abbey, with Nelson's tower at Forres, built in 1806, in the distance. Throughout the ages, Kinloss has been involved in world affairs and politics. In the sixteenth century the famous Abbot Robert Reid, founder of Edinburgh University, created a seat of learning and culture at Kinloss Abbey. Nowadays, the abbey grounds provide a final resting place for those who died in the Second World War when serving at local airfields. Practical and financial reasons during wartime prevented their remains from returning home for burial. RAF Kinloss was a Second World War bomber training centre, becoming a Maritime Operational Training unit until 1965. Until late 2010 Nimrods, 'The Mighty Hunters,' were based at RAF Kinloss. The Aeronautical Rescue Coordination Centre is based here.

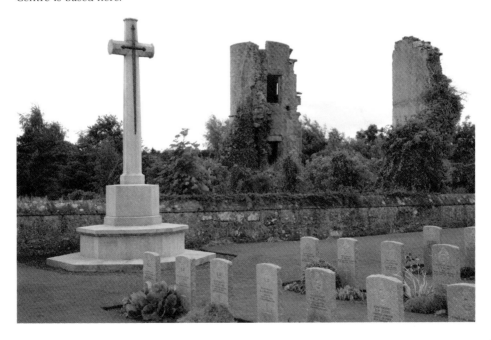

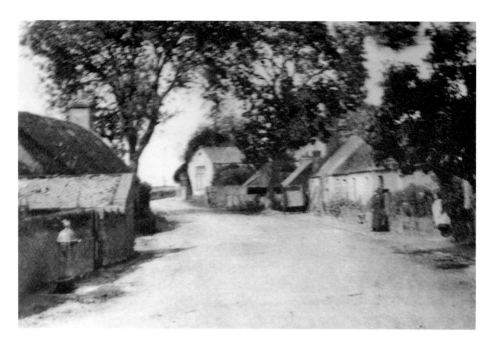

The Abbey Inn, Kinloss

The present sixteenth-century Abbey Inn was built with stones from the nearby ruined abbey. On the road to Findhorn village, it was once a row of cottages, a bakery and eventually a pub in the 1950s. Kinloss Abbey was founded by King David I in 1150, after he became lost when hunting and was guided by a dove to nearby shelter. There he had a dream telling him to build a chapel. The resultant abbey was Cistercian, the white-robed monks creating a library, gardens, orchards, mill, brewing house and farmlands. Famous visitors in its 400-year history include Edward I and, later, Mary Queen of Scots. Religious reform in 1560 meant dissolution, and stones from the ruins were later used to build Inverness Citadel.

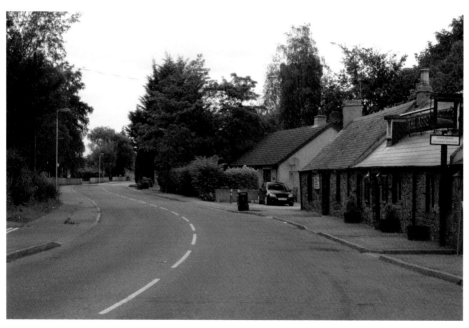

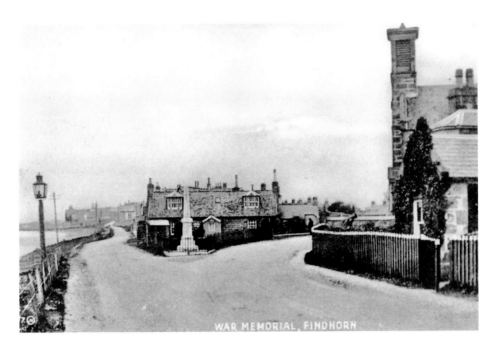

WAR MEMORIAL, FINDHORN.

Findhorn War Memorial

Just before entering Findhorn village is the site of an 1866 cholera hospital, now a private house. On the right, opposite the War Memorial, the 1843 church was originally thatched, and the foundations and walls were created from large stones once used as ballast in the trading ships that used the harbour. Built in 1859, the railway track ran along the shore line to the harbour, but was not a commercial success. The track was lifted in 1873. Findhorn village was unaffected during the Great Moray Flood of 1829 but, showing extreme bravery, Findhorn fishermen sailed across the fields in incredibly hazardous conditions as floodwaters raged over the countryside. Their bravery saved the lives of many people and livestock.

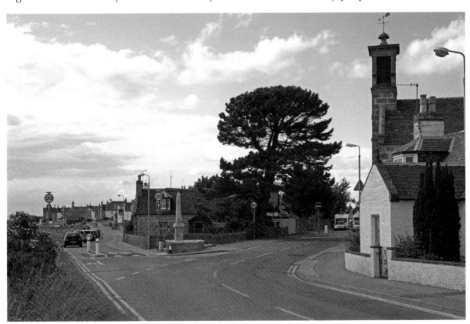

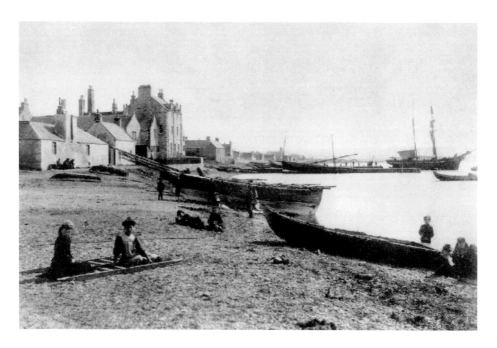

Looking Towards Forres, Early 1900s and Early 2000s

The old port of Findhorn, once a mile north-west from its present position, was a busy sea port trading from the Baltic to the Mediterranean. It was used by Elgin merchants for their imports and exports until towards the end of seventeenth century, when their trade was diverted to Lossiemouth. Findhorn then became the primary trading port for nearby Forres merchants. Coal was imported from Sunderland. Flax, tow, iron, soap, ropes and dressed hemp came from Aberdeen and Leith. Sugar, tea, hops, porter, silk hats, ribbons and buttons came from London. Principal exports were grain, locally dyed thread, salmon, timber and eggs. Although primarily a trading seaport, Findhorn in the nineteenth century was also a flourishing fishing port, dealing with herring and salmon.

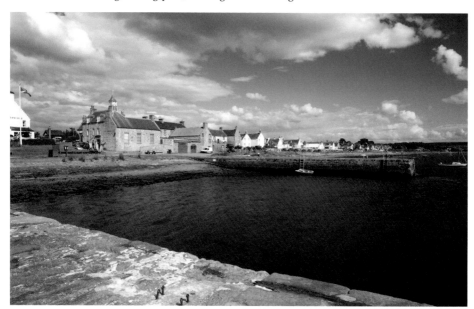

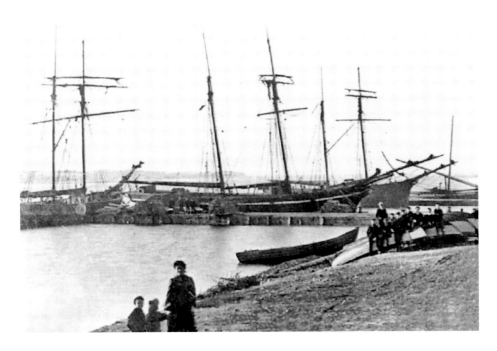

Findhorn Harbour, 1890s and 2010

As demand increased, vessels were forced to wait off-shore. A new harbour and pier was eventually built in 1830. The north pier was used by fishing vessels, the south pier used for Aberdeen-, Leith- and London-bound ships. From 1837 oak and larch from the nearby Darnaway estate was used in the Findhorn shipbuilding industry. The associated businesses of sail and rope making were set up, along with the cooperage for the herring fishing industry. Towards the end of the nineteenth century, Findhorn bay grew increasingly shallow and tide-bound. Navigation became difficult, and, coinciding with improved rail and road transport and the consequent downturn of the merchant fleet, Findhorn harbour began to decline. Fishing boats became larger and moved to Burghead.

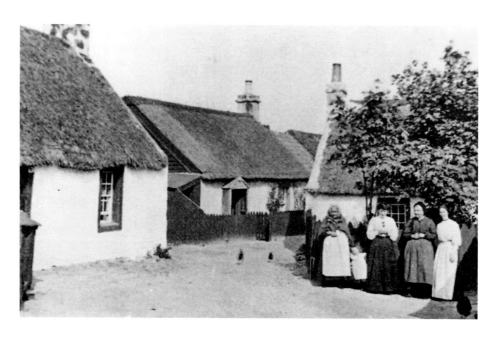

The Old Villages of Findhorn, 1912 and 2010

Aware of the shifting sands that threatened the community at the end of the seventeenth century, the villagers began to move. In the process, many of the new houses were built from stones taken from the old village. The new Findhorn developed steadily. With the growth of the new harbour, the trades associated with shipbuilding and fishing, such as coopers, and shops of butchers and bakers were set up. In 1842 a minister disapprovingly recorded thirteen pubs and whisky shops! Fishwives from Findhorn sold fish and locally cured herring – speldings – from their creels at the steps of the Forres market cross until the late 1920s. In 1972, the settlement of eighteenth- and nineteenth-century houses were designated a conservation area.

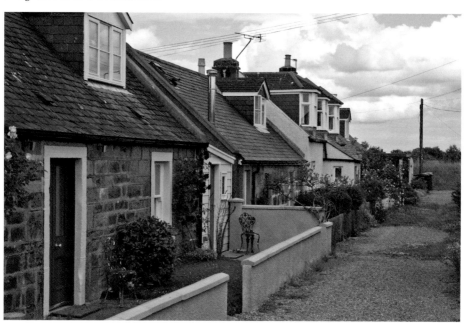

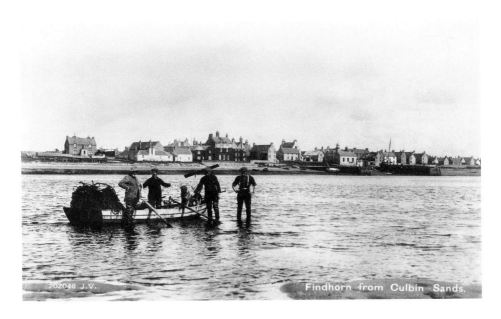

202046 J.V. Findhorn from Culbin Sands.

Towards Findhorn and From Findhorn

Findhorn was the control centre for salmon fishing from the 1930s, and two companies employed more than a hundred men – most living in bothies along the coast during the salmon season. Flat-bottom boats were used to collect salmon from off-shore nets, and the fish were stored in an ice-house. In the mid-nineteenth century, around 600 boxes containing 34 lb of salmon packed in ice were shipped annually to London. A smaller ice house was used as a hatchery, and to store and prepare fish awaiting rail shipment south. Commercial salmon fishing was discontinued here in 1987. The larger ice house, now an ancient monument, is part of the Findhorn Heritage Centre, whose volunteers ensure the rich history is preserved and accessible.

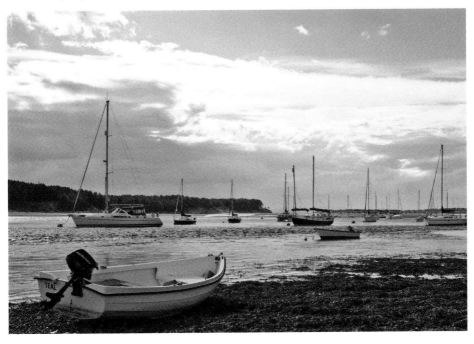

The Old Fishing Fleet and the Shifting Sands

By the end of the seventeenth century, the drifting sand which swallowed nearby Culbin turned the course of the River Findhorn west. Realising the danger, the villagers began relocating to Muirtown before a huge storm in 1702 caused the blocked river to burst through and sweep over the old settlement. The old seaport was inundated. The port was rebuilt, but declined in the nineteenth century when the bay became shallower. During the Second World War, nearby farmland was requisitioned and the coastline from Burghead along the Culbin coast was used for military training for D-Day. Nowadays, the Royal Findhorn Yacht Club overlooks the pleasure craft in the bay while windsurfers, birdwatchers and naturalists can pursue their interests in this idyllic location.

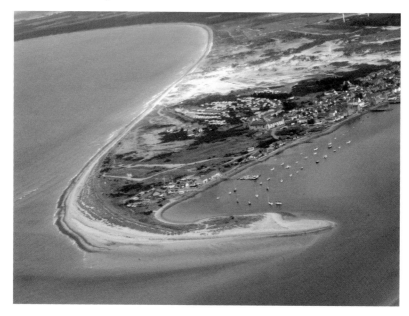

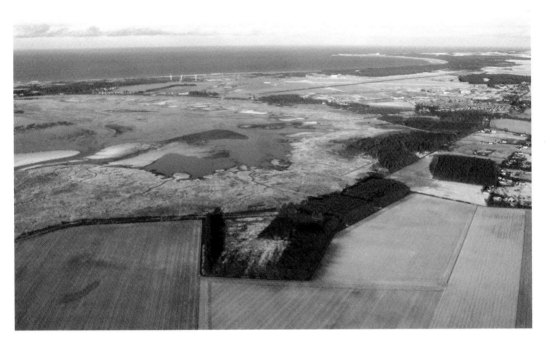

Recorded in Stone, and Sands of the Findhorn Estuary

Flint arrow-heads, barbed tools and other artefacts found in this area that date from 7,000 years ago can be seen in Findhorn Heritage Centre and Forres Museum. Now covered by a glass case, at over 6 metres high, Sueno's Stone is the tallest piece of medieval sculpture in Scotland. Less than a mile inland from Findhorn Bay, this complex Pictish carving, with a Celtic cross on one side and detailed battle scenes on the other, demonstrates the importance of this area in the ninth century. Modern monoliths seen in the aerial photograph are the windmills of the Findhorn Foundation – the community founded in 1962. The community has grown into an internationally recognised eco-village, spiritual and educational centre, with a modern art gallery and hosts a variety of international conferences and concerts. The mudflats and salt marsh of Findhorn Bay Nature Reserve provide an internationally important haven for wildlife.

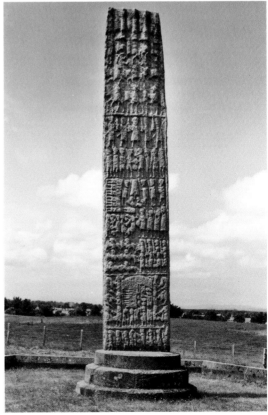

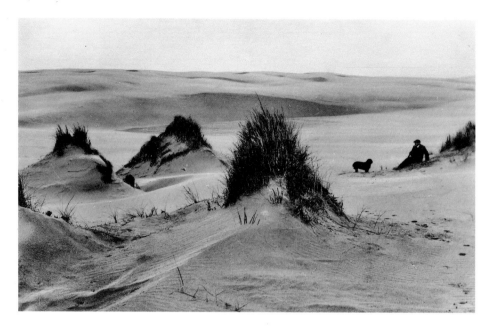

Shifting Sands of Time

The vast amount of sand in this area is the result of a tsunami 8,000 years ago. Shell-middens, flint arrows, spindle whorls and Iron-Age glass beads are amongst the ancient artefacts found here. Farming was attempted in this area, but the cutting of coastal turf and removal of marram grass for thatching resulted in the exposed land becoming more vulnerable to devastating storms. By the end of the seventeenth century, the massive dune system had evolved. These 14-km-long Culbin dunes were constantly changing and subject to many lurid legends! The Forestry Commission took over the area in 1922, stabilising the sand with branches and planting pine trees, creating varied and rare wildlife habitats as well as a unique place to explore.

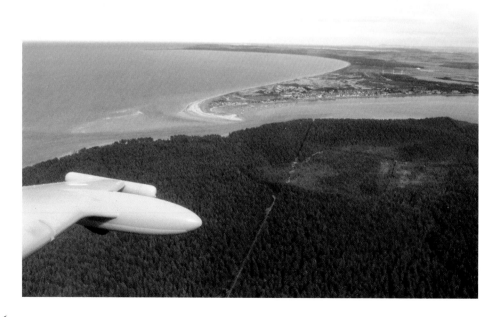